Comedia Series ● – 44

SATURDAY NIGHT OR SUNDAY MORNING?

From Arts to Industry – New Forms of Cultural Policy

by Geoff Mulgan and Ken Worpole

Comedia Publishing Group
9 Poland Street, London W1V 3DG Tel: 01-439 2059

Comedia Publishing Group was set up to investigate and monitor the media in Britain and abroad. The aim of the project is to provide basic information, investigate problem areas, and to share the experiences of those working in the field, while encouraging debate about the future development of the media. The opinions expressed in the books in the series are those of the authors, and do not necessarily reflect the views of Comedia. For a list of other Comedia titles see back pages.

First published in 1986 by Comedia Publishing Group
9 Poland Street, London W1V 3DG.

British Library Cataloguing in Publication Data
Mulgan, Geoff
 Saturday night or Sunday morning? From Arts to Industry – New Forms
 of Cultural Policy
 1. Labour Party—Great Britain 2. Art and State—Great Britain
 I. Title II. Worpole, Ken
 700'.941 NX750.G7

ISBN 1-85178-021-1

Cover Design by Windhorse Associates

Distributed in the UK by George Philips Ltd., Arndale Road, Lineside
Industrial Estate, Littlehampton, W. Sussex
Distributed in Australia by Second Back Row Press, 50 Govett Street,
Katoomba, N.S.W. 2780
Distributed in Canada by D.E.C., 229 College Street, Toronto, Ontario

Typeset by Photosetting, 6 Foundry House, Stars Lane, Yeovil,
Somerset Tel: Yeovil 23684

Printed in Great Britain by Unwin Brothers Ltd., The Gresham Press,
Old Woking, Surrey

Contents

Acknowledgements

To the memory of Carl and Paul Drewer

"Walls come tumbling down"

Particular thanks to Lisa Appignanesi, Franco Bianchini, Peter Jenner, Naseem Khan, Neil Spencer and Alan Tomkins.

Introduction

I suppose we could define the present crisis facing the arts in Britain today in a number of ways: the appalling shortfall in necessary public funding, for example; or the push towards sponsorship with all the distortions that that will bring about; or the failure to expand our definitions so that broadcasting, film, popular music, community arts are left out of what passes for an arts ministry in Britain; the failure to understand the consequences of the new technologies; the patronage concept within our structures of administration; the narrow domination of ideas from within establishment London; the fear of using the word "culture"; the creation of a permanent conceived dichotomy between a "high" and "low" culture, between the respectable and the "vulgar"; the false division between what is professional and what is not, between that which is "good for them" – and that which we want to create for ourselves. In short, some will argue, this is simply once more the classic "us" and "them".

But even that would be only half the story. The real tragedy is that while the "them" might be pretty clear what they want, the "us" have to far too great an extent not only surrendered the position but have actively aided in their own cultural dispossession. Mulgan and Worpole rightly criticise the left and the Labour movement for their own failure. But it is of course a failure endemic in the Labour Party's frequent boastfulness about their own *lack* of theory, not only in this field, but along the entire political and economic spectrum. One does not easily forget Harold Wilson taking pride in never getting past the footnotes on page 17 of *Das Kapital*.

This book takes all of that head on. And it starts with a certain confidence. Things have been done. They are not simply theorising. And the things that have been done were, of course, done during the short-lived period of the Mets and the GLC. It was from their experience that this book arose.

And by no means the least important part in the book is the precise lessons the authors draw from that experience. They outline the practical steps for an incoming government willing to learn from and put into practice on a national scale much of what has been done during these years. Above all, there is the simple lesson that such a radical policy can work; that it far transcends a narrow arts policy; that it is a necessary and achievable and integral part of an entire social policy.

They refuse to accept that such a radical policy is only about access. Or that if we were only to carry out the post-war policy of Keynes then all would be well. This was the "distribution" model, i.e. that the task was to carry music, drama and pictures to places which would otherwise be cut off from the masterpieces . . . to factories, to mining villages . . . In other words that model was defining the problem of cultural democracy as being simply the distribution of access to culture — not the problem of what constitutes that culture.

They make no bones about the social and economic importance of the arts. Why, they argue, should this be seen as an inferior argument to the old "Leavisite" and even older Matthew Arnold arguments for the arts as being good for the soul of the nation or for the moral good of the working class? And of course the book rips open the eventual conclusion of these arguments — that it ends up as preservationism only, or with "centres of excellence" that, by some unexplained process of osmosis will percolate through and transform the consciousness of the nation. And equally that would have meant, of course, removing the "arts" from the mainstream of actual cultural activities. Reith promised "there will of course be no jazz on Sundays". Popular art forms have had to bulldoze their way into the consciousness of the Arts Council. "New cultural forms," say Mulgan and Worpole, "always seem to produce frenetic moral panics." The result, they say, is that "the Arts Council has condemned itself to a semi-permanent crisis, both economic and cultural".

The book analyses the basic power apparatus behind not only "high" culture but popular culture. It recognises the contradiction between mass access and mass participation; between say, listening to broadcasting now (or in the future, with cable and disc and satellite) and the lack of access in terms of the means of popular and democratic control. In this situation "frenetic moral panic" means capitulation. This aspect of the book is particularly relevant at the present time, following upon the Peacock Report. Radical thought is inevitably torn between the defence of the BBC at the present time, as being the defence of public service broadcasting, and a recognition of the gross inadequacies in any real democratic accountability, and the lack of real diversity in access within the existing duopoly. Half an hour of "The Right to Reply" is hardly an excess of participation. They quote D. G. Bridson when first asked to work for the BBC: "I mentally bracketed it with Parliament, the Monarch, the Church and the Holy Ghost." Well, the holiness has gone — but the establishment remains. What the book poses therefore is the why and the how of a radical and popular cultural democracy.

They call upon their experience with the Greater London Enter-

prise Board and the GLC to demonstrate the link between cultural
and social policy, economic policy and employment policy. They
argue therefore not only the rightness of such a policy but its crucial
centrality. The GLC applied such a policy, noting elements of area
social deprivation as one of the factors in the allocation of funding
support. And then found it worked, not just as a social policy but in its
own right as a cultural policy too:

> "In the original 160-page manifesto for the 1981 GLC
> election, the arts received a mere quarter page of attention . . .
> Yet at the end the arts programme had become the flagship of
> the GLC's radical political and economic policy — commit-
> ted to public growth and a programme of equal opportunities
> and positive discrimination in favour of London's many
> minority communities — rather than a minor embellishment
> on a different kind of political programme."

There is a lesson here for a future Labour government. And some-
times the authors spell out the lessons in meticulous and useful detail.
The problems they were faced with in existing local government
legislation, for example, which created a kind of appalling Duke of
Edinburgh's scheme of endurance and difficulties. Their guide
through some of the labyrinth involved in this remains useful. Even
more useful perhaps is their conclusion: "The reform of this legis-
lation should be the first priority of any new Minister with respon-
sibility for the arts."

For sure this book will act as a guide to such a Minister. But
equally important, it should act as a guide to local authorities and
others involved in the here and now of arts development. Mulgan and
Worpole ask: "Where is the arts equivalent to the massively success-
ful 'sports for all' campaign?" This book will begin the process of
answering their question.

I welcome this book both for its theoretical and its practical
virtues.

I believe it will prove to be a major contribution towards redefining
both our concepts and our tasks within the arts today.

I also believe it will provide a more than useful handbook of guidance
for those actively engaged in developing a socialist arts policy for
Britain.

I welcome it above all because it says loudly and clearly: "Look here,
the arts matter! The arts are for all!"

It was never more necessary to assert that than today.

Norman Buchan
Shadow Minister for The Arts

"There will never be jazz on Sundays." Lord Reith

"For it was Saturday night, the best and bingiest glad-time of
the year, one of the fifty-two holidays in this slow-turning Big
Wheel of the year, a violent preamble to a prostrate
Sunday."

Alan Sillitoe, *Saturday Night & Sunday Morning*

New definitions for old

Who is doing most to shape British culture in the late 1980s? Next Shops, Virgin, W. H. Smith's, News International, Benetton, Channel 4, Saatchi and Saatchi, the Notting Hill Carnival and Virago, or the Wigmore Hall, Arts Council, National Theatre, Tate Gallery and Royal Opera House? Most people know the answer, and live it every day in the clothes they wear, the newspapers they read, the music they listen to and the television they watch. The emergence (and disappearance) of new pursuits, technologies, techniques and styles – whether windsurfing, jogging, aerobics, Zen, compact discs, angling, wine-making, CB radio, rambling, hip-hop, home computing, photography, or keeping diaries – represent changes that bear little relation to traditional notions of art and culture, and the subsidised institutions that embody them.

With the special exception of broadcasting, state policies have for too long been directed to only one small corner of this world – the world of theatres, concert halls and galleries. It is as if every energy has been directed to placing a preservation order on a Tudor cottage, while all around the developers were building new motorways, skyscrapers and airports. In this, Labour has always been complicit. It has failed to make the links between the old arts and the new, electronic forms. It has failed to break out of the false divisions between high and low culture, and has never challenged the power of the tiny, metropolitan elite which views the world of the arts as its own private playground. Nor do traditional socialist solutions have much to offer. The prospect of nationalising newspapers, record companies and advertising agencies is rightly viewed with enormous suspicion. The idea that 'art' can simply be mobilised in the service of socialism has little resonance in an age when the most radical liberation struggles around gender, race, sexuality, disability and imperialism have only a partial relationship to a socialist hegemony.

Yet after years of electoral decline there is a dawning awareness that socialism without a cultural programme is a barren project. Unable to muster visions and fictions, the economic programmes for change lose their resonance, and become just so many more new – and possibly unreal – figures and false promises. Throughout its history, reflecting its base in workplace organisation, the Labour Party has

been lukewarm about culture. The rich and varied heritage of the Chartists, William Morris and the Socialist League, the Clarion Clubs, the ILP choirs, the workers' theatre movement, was never incorporated into the kind of all-embracing party culture of the other great European socialist parties like the Swedish or German SDPs and the Italian PCI. When in power Labour has mostly promulgated bi-partisan, 'non-political' arts policies. Its key interventions have been in support of Covent Garden rather than working-class culture. Its radicalism has taken the form of calls for more spending on the arts, though in practice this has involved an even greater transfer of resources from working-class taxpayers to subsidise the pleasure of the metropolitan elite.

The price paid for the absence of a coherent socialist perspective has been marginalisation. While the Arts Council funded a few more theatres and the occasional touring opera companies, the real popular pleasures have been provided and defined within the market-place. The cultural industries which produce the words, sounds, images and meanings that surround and bombard us have been immensely dynamic in recent years. The Marxist superstructure, the realm of ideas and ideologies, has become a primary motor for the economic base. Converging around the television set a host of new, information-based industries is growing up, linking computing, telecommunications and the diffusion of culture. In this context the marginalisation of state intervention and the artificial governmental divisions between art (The Office of Arts and Libraries), the economy (Treasury and Department of Trade and Industry), broadcasting (Home Office) and education (Department of Education) have left the commercial market-place with all the best tunes. While the state concentrates on a fairly limited opera repertoire and a Shakespearian heritage for the tourists, the corporate planners and strategy executives of the multi-nationals are only too keen to write the real cultural policies for themselves.

The worst result would be a two-tier culture: on the one hand a world of subsidised or sponsored arts and public service broadcasting for the elite, and on the other commercial, mass produced, largely imported culture for the rest. In this book we argue for an alternative based on supporting the rich diversities of cultural activity in Britain within all forms of culture, popular and traditional. We argue for a shift away from the traditional, patronage-based models of funding towards new forms of investment and regulation more suited to the realities of culture as a modern industry, and geared to the in-dependence of those who make culture. These policies are not blind to the fundamental politics of culture so vehemently denied by the arts elite. The traditional bipartisan approaches have allowed dominant

ideologies and institutions to dominate. They have failed to recognise the massive social power of culture for those on the receiving end of material and ideological oppressions, and the ways in which struggle takes place within commercial forms and the market as much as in the corridors of the state.

We are told that the Labour Party is a broad church, one that owes more to Methodism than to Marx. Both assertions are probably true, in that culturally the Labour Party often seems to have more in common with a poor and puritanical sect than a modernising popular movement. Along with many non-conformist churches it seems to share the same dwindling network of shabby local buildings, an evident doctrinal hostility towards popular diversions and pleasures, an obsession with protocol and organisational procedures, and a fear of the modern. Across the board Labour is in need of new directions and new sources of energy. The old methods of policy-making, wheeling and dealing behind closed doors between a handful of senior male Labour politicians and a few male trade union general secretaries, can no longer deliver the goods even if they were politically excusable. But taking a hard look at future prospects doesn't necessarily mean dumping the past.

When we have looked back through such histories of the Labour Party as exist, or the biographies and autobiographies of some of its most influential members and leaders, we have had to search very hard for any reference at all to thinking on cultural policy, or indeed any aspect of popular culture and social life other than work, housing or international affairs. The very name of the party, the *Labour* Party, betrays its origins as the political wing of the organised trade union movements and the specific needs of 'labour' rather than 'people': for the first thirteen years of its life, it was only possible to be a member of the party through a union. Not surprisingly, its origins reflect almost exclusively the interests of employed male trades unionists. But in Britain today waged workers are a minority, and even waged workers have lives outside of the work they do. This one-dimensional aspect of the Labour Party's social formation is badly in need of new forms of enrichment, a new spirit of ecumenicalism.

It was of course puritanism that defined life as work – and work as life. Salvation would come only through hard work and self-denial. Everything that was not work was suspect, particularly idle time and social pleasures. That puritan ethic somehow got lodged into the skin of the Labour Party, like a piece of grit is trapped into the membrane of an oyster. Yet it failed to produce a pearl. Along with the emotional and organisational heritage of puritanism and non-conformism, came the associated ideologies of teetotalism, austerity in food and dress, an antipathy towards music, dance and the theatre, and an

antagonism towards the escapist novel and other fictional worlds. This was a fairly heavy piece of ideological baggage to have to carry everywhere you went, particularly in the twentieth century.

People cannot simply be defined by their work, or, as it is often expressed, their 'objective position in the social relationships of production'. As Sartre once reminded some over-doctrinaire Marxists, people are not born working class, 16-years-old and waiting outside the factory gate; they have childhoods too. Over half the population are women, all of whom work but the majority of whom have worked in ways which have excluded them from trade union organisation, and even pay. Many people are of employable age but cannot find work. By the year 2050 over half the population will be over sixty. The 'working class' is no longer an adequate description either of a homogeneous body of people, or of a hegemonic political formation ready to march when called.

Since 1945 the blooming emporium of the commercial market has beckoned people away from the certainties of British puritanism. The Conservative Party, though often caught between moralistic paternalism and the free play of the market, has taken great care to identify itself as being responsible for the pleasures of consumption. Labour Party puritanism has failed to understand exactly how liberating (and we've chosen the word carefully) some patterns of consumer spending have been. Sensitive social historians of the post-war working-class, such as Carolyn Steedman, Elizabeth Wilson and Jerry White, have shown in detail how the growth of cheap fashion clothes, make-up and even small amounts of additional spending power gave many working-class girls in particular a real sense of self-confidence and independence.

American popular culture also helped too. American detective novels, films, dance band music and early rock 'n' roll possessed an energy and populist radicalism that Agatha Christie murders, Gainsborough Studios costume films, Ealing Comedies and the BBC Light Orchestra clearly didn't. Since 1945, though the currents were there before, fashion, style and political rebellion have been inextricably linked. In America in the 1940s black musicians and politicos adopted the outrageous Zoot suits as a way of expressing defiance and scorn at white 'decorum', precipitating 'Zoot riots' in some cities. Within a few years English teddy boys had adopted the same style, together with American music, and caused a few headaches for authority here. In occupied Paris, rebellious teenagers known as Zazous listened to American big band jazz, greased their hair down with salad oil, dressed in long coats and tight trousers, and ridiculed the puppet Vichy regime. By the late 1950s even the Soviet Union had problems with its own zoot-suited Stiliagi, with broad-

shouldered jackets, black shirts and thin white ties, thick-soled shoes and a passion for jazz. Since then, popular music and politics have danced in fairly close time together around the world.

That long-standing tension between political seriousness and 'self-indulgent' pleasure was captured for post-war Britain by Alan Sillitoe's celebrated novel, *Saturday Night and Sunday Morning*, from which we have adapted the title of this polemic. It also has an earlier history. When Charles Kingsley visited a Chartist bookshop in the 1840s he was shocked to find alongside the political tracts and earnest journals, copies of *Flash Songsters*, *Tales of Horror*, and "dirty milksop French novels". In the 1890s, in the hundreds of working men's clubs throughout Britain, it was frequently reported that people wouldn't turn up for the lectures unless the bar was going to be open afterwards. Too much Labour propaganda has suggested that under socialism every day would be a Sunday, full of earnest endeavour, talks and lectures, leaving market-place capitalism the job of offering the illicit pleasures of what Marie Lloyd so aptly described as 'sweet Saturday night'. Popular culture and puritanism (whether led by the church or the state) have been in almost perpetual conflict since the sixteenth century. It is an expensive irony of our history that the party of the people inherited only the puritan tradition, leaving to entrepreneurial capitalism the lucrative pastures of popular culture.

This short book arises out of the work we have both been involved in, firstly at the GLC Community Arts Sub-Committee and then latterly at the Cultural Industries Unit at the Greater London Enterprise Board (GLEB). It is an account of one particular set of arguments about cultural policy based on our direct experience in two different forms of local government provision. For this reason we have not dealt in detail with the work of the two other Sub-Committees of the Arts and Recreation Department now abolished at the GLC, the Ethnic Arts Sub-Committee and the Sports Sub-Committee, though their achievements were as important as any others in the innovatory administration between 1981 and 1986.

We are concerned, however, that this set of arguments does not inadvertently contribute towards a further mythologisation of the GLC administration in which only glowing successes are described, and the difficulties and failures conveniently omitted. Distance (and time) lend enchantment to the view, and it seems that it was easier at times to support the GLC from a distance than from inside. It was a pioneering and courageous administration, and the mark of its radicalism was that it was fraught with argument and the clash of sectional and political differences being aired and contested. As Stuart Hall observed of GLC politicking at the time: "The ding dong,

complaints, pressures, pushing and response between the movements and the politicians is the positive sound of a real as opposed to a phoney and pacified democracy at work."

One clear reason for much of the early sound and fury which greeted the GLC's new arts policies was that it effectively ended a long period of political bi-partisanship on arts funding. It was suddenly no longer the case that the only difference between Labour and Conservative was about the scale of spending. The response to policies which argued for re-directing funding away from the major institutions to more localised and community-based activities produced outraged headlines in the national and local press: "Tourists will stay away, says Tory", "GLC aid for street-theatre weirdos", "You don't expect civilised people to behave like that, says Sir Roy Strong." A continued policy of re-distribution of resources is likely to be even more controversial at a national level unless wholly new sources of funding are brought into the arts equation.

We believe that there *are* such new sources once one gets away from a preoccupation with the "subsidy mentality", and looks toward other kinds of arts and cultural development in terms of job creation and industrial development. The phrase "the cultural industries" is not just a fashionable catchword. The forms of culture which the majority of people now use and through which they understand the world – radio, television, video, cable, satellite, records and tapes, books and magazines – are produced by industrial processes no different from any others. What was once thought of as the ideological superstructure has now become a significant part of the economic base. To buy a Style Council or Kiri Te Kanawa record, a new book by Fay Weldon or Alice Walker, to watch a Victoria Wood programme or a Channel 4 film on television, involves standing at the end of a massive line of producers and printers, tape operators, scriptwriters and sleeve designers, printers, engineers, camera crews, promoters, record pressers, distributors, lawyers, accountants, musicians and editors, not to mention the people who designed and made the hardware on which the music, film or book was recorded, printed or watched. More people are employed in broadcasting than the entire computer industry. Copyright earnings (the work of writers, composers, graphic artists and illustrators) account for a larger proportion of the GNP (2.6%) than the motor industry or food manufacturing. At least half a million people are employed in some form of cultural production, distribution or infrastructure, and it is one of the few growth sectors of the economy.

The challenge to Labour is to develop policies that are at the same time industrial and aesthetic. As always, socialist and radical ideas are widely supported among workers in the cultural industries. Most

would welcome policies to increase employment and sustain their independence from predatory entrepreneurs. Never before has multinational capital been more hungry to reach out into new areas, to dismember public service broadcasting and buy up Fleet Street, to commercialise educational provision and even religion, and to establish concentrations of power across the whole field of culture and communication.

Labour local authorities have been in the forefront of the campaign to develop new policies for the cultural industries. A number have invested in local recording studios and film and video production companies; others have used contract compliance schemes and planning permission levers to ensure that media companies develop equal opportunity policies and community access provision; many now fund through grant or loan independent publishing initiatives in local history, or for women, gay or ethnic audiences. It is salutary to remember that of the twenty titles selected for Feminist Book Fortnight in June 1986, seven came from small publishers in receipt of local authority funds. We have argued elsewhere for recognising the vital political and cultural importance of the 'independent sector' in publishing, records and films, and it must be a Labour priority to make large funds available to this sector, if there is to be any serious programme of cultural diversity. As in the past, local authorities, so often seen as dull and hidebound, have been far ahead of the more prestigious national institutions.

We have said very little so far about the press, traditionally the dominant concern of the left in the area of modern mass communications. This is largely because the arguments exist so strongly elsewhere, through the work of important pressure groups such as the Campaign for Press and Broadcasting Freedom, that we felt that we might simply be repeating already agreed positions, whereas in the field of what are termed the cultural industries, many of the arguments developed over the past three years have not been so widely disseminated. We have also said little about the theatre or the visual arts. Our aim has not been to provide a comprehensive programme or blueprint, but to argue for change in approach and a moving of the goal posts. If we have ignored the traditional areas of arts funding it is not because we are against the theatre or galleries or to see the struggle over resources as one between recording studios and sculptures, or between the Royal Shakespeare Company and community radio. Any rational method for social accounting able to describe the direct and indirect benefits that accrue from cultural activity would sustain an argument for far more resources for all forms of culture.

If we have stood back from blueprints it it and innovation with policies and institutions. Some will fall on fertile ground and survive,

while others will fail. But unless we get to grips with the dynamics of the cultural economy, we will find ourselves fighting Darth Vader with an armoury of bows and arrows.

State policies and the arts

"The modern world is alien to the English temperament."
(J. B. Priestly)

The origin of most local and national government legislation about the arts and cultural provision can be found in the nineteenth century. The Museum Act of 1845 and the Public Libraries Act of 1850 were the founding pieces of cultural legislation in this field. And although there is no doubt that at the time they marked a great step forward, they were finally put on to the statute book for a variety of motives, not all of them good.

Reformers' arguments that working people had a right to admire and learn from the work of the great archaeologists, scientists, historians and explorers lay behind the establishment of national and local museums throughout Britain in the middle of the nineteenth century. In 1816 Tory MP J. W. Croker argued that the acquisition of the "Elgin" Marbles and their public display would elevate the mind of the English labourer. Lord Shaftesbury believed that once the National Gallery was built the working classes would desert the pubs in favour of the studied contemplation of the works of Titian and Reynolds. It was also argued, from a more genuinely liberal position, that working people had a right to "free" knowledge and self-education through access to local libraries.

On the other hand, museums were also a part of an education into an imperialist mentality, and a celebration of that rapacious Victorian desire to plunder other societies and other cultures. Paradoxically, the urge to collect and classify helped accelerate the process of extinction for many species of natural life. Inasmuch as people learned about other worlds and other times, through the use of museums, they also consciously or sub-consciously learned about their own insignificance and powerlessness. The zeal to establish libraries sprang not only from liberal ideals of universal knowledge, but also from rather more dubious motives to do with challenging, and possibly destroying, indigenous forms of popular culture, particularly those aggregated around radical politics, street entertainments, and pub and club life. The public provision of museums and libraries, the

temples of nineteenth-century culture, was therefore part of a broad programme of moral regulation and social control.

For many local authorities, however, both Labour and Conservative, the museum and the public library service have continued to represent almost the full extent of a local government arts and cultural policy.

As a result of a strong radical tradition within librarianship, many libraries have gone out of their way to meet the needs and interests of local people, and at a take-up rate of, on average, 40 per cent of the population who regularly use their public library service, it should be said that the public library system in Britain is, with the exception of broadcasting, possibly the most successful form of state cultural provision. The museums service has been rather slower to adapt to popular interests and concerns, although in recent years the expansion of "open-air museums", "living" museums and a more active approach to educating and entertaining people, through the museum provision, has resulted in greater and more enthusiastic attendances.

The Labour Party's first manifesto to mention the arts was the 1918 document "Labour and the New Social Order". This argued that major public spending on the arts was necessary "for the promotion of music, literature and fine art, which have been under capitalism so greatly neglected, and upon which, so the Labour Party holds, any real development of civilisation fundamentally depends". These arguments were still nineteenth-century liberal arguments, however, and seemed quite unaffected by the work and ideas of William Morris, whose revolutionary socialist position had been against *fine arts* from above and for *popular crafts and cultural production* from below. Morris also wanted to link the socialist position on culture with its position on work, and the quality and usefulness of that work. In modern jargon, he was saying that a socialist cultural policy was by definition a policy on employment too, and that the aesthetics of production were infinitely more important than the aesthetics of consumption.

The manifesto bore fruit in the first (minority) Labour government of 1924, under Ramsay Macdonald, which proposed to give local authorities powers to spend the product of a penny rate on the provision of arts and entertainment facilities. Significantly, the commercial theatre lobby, then very powerful, managed to ensure that the House of Lords amended the proposed legislation that local authorities in fact could not provide entertainment, but could only spend money on sport and recreation. The Tory MP Sir Charles Oman (MP for Oxford University!) pronounced at the time that the Roman Empire had collapsed precisely because free entertainment

was added to the free dole. As Hugh Jenkins more recently commented on this significant amendment: "Commerce, of course, has always sought to confine public enterprise to loss-making activities." That constraint on local authorities to fund cultural provision only by underwriting losses, by grant or subsidy, remains embodied in the legislation still in use today. Local authorities such as the GLC and Sheffield Council have experienced enormous legal difficulties when attempting to make commercial loans to socially desirable but commercial forms of cultural provision such as recording studios, video production companies, and so on. This was a key reason why, for example, the GLC came to use the Greater London Enterprise Board, a semi-independent investment company, to intervene in this area of commercial cultural production.

The Arts Council

Conscious of the many First World War promises which had failed to materialise, greater efforts were made from the beginning of the second great war to inculcate both the conscripted and civilian populations with the democratic values which Britain was supposed to be defending. Inherent in those "values" were national traditions of art and culture. Hence the formation in 1938 of ENSA (the Entertainments National Service Association), made up of conscripts from the variety and theatre worlds, and in 1939 CEMA (the Council for the Encouragement of Music and the Arts).

The original brief for CEMA was to encourage amateur music, drama and painting, particularly in the provinces. This was done through grants to bodies such as The Music Travellers, who toured Britain setting up music groups (what we would probably today regard as music workshops) and to the Institute of Adult Education for its "Art for the People" programme. However, CEMA rapidly came under the influence of professional organisations, and was diverted into becoming a sponsoring and funding body for professional arts only. In the Annual Report for 1951-2, there was a striking reference to the "problem" of amateur theatre: "To the many problems the theatre has to confront in the provinces there seems to be added nowadays the mounting strength of the amateur theatrical movement." Even so, even the small sums of money awarded to the arts by CEMA were too much for the *Daily Express* of the time. "The government," it raged, "gives £50,000 to help wartime culture. What madness is this? There is no such thing as culture in wartime!"

CEMA's second chairman was the liberal economist John Maynard Keynes, who consolidated the new "professionalism" by

describing its role as being "to carry music, drama and pictures to places which would otherwise be cut off from all contact with the masterpieces of happier days and times; to air-raid shelters, to war-time hostels, to factories, to mining villages . . ." This was the "distribution model" of culture writ large: the problem of cultural democracy was simply about the distribution of access to culture, not what actually constitutes that culture in the first place. So if you could take Milton to the mines, Fidelio to the factories and Shakespeare to the shelters, everything would be solved. And though there is no doubt that this policy did produce important cultural rewards, the tap could be easily turned off. Amongst several South Wales miners' autobiographies can be found memories of the war-time touring productions of the Old Vic with Dame Sybil Thorndike. But when the war ended so did the liberal touring policies.

In 1945 the organisation that had been CEMA became The Arts Council of Great Britain (ACGB). It was given a Royal Charter, and the war-time systems of staff and advisory appointments by self-recruitment amongst the great and the good, became its continuing practice. To this day the Arts Council has resisted all calls for greater public accountability, through any form of regional representation, or by professional or organisational interest, and remains a self-appointed and self-perpetuating metropolitan clique. As Robert Hutchinson wrote of the founding members, ". . . select groups of mice were given the responsibility for distributing the cheese. Vested interests were fully involved in the Arts Council's decision-making from the outset, not as representatives or delegates, just as vested interests." Even such de-centralised features of the early CEMA, such as its regional offices, were closed down confirming the widely held opinion that the Arts Council was both London based and London biased. To this day London receives three and a half times as much money *per capita* as the next best provided region (Merseyside) and nine times as much as the least provided (Eastern Arts). The underlying bias of its members against forms of popular culture was buttressed by a realisation that it would just not be feasible to make any intervention in that area. As the report on the Council's first ten years put it: "The Arts Council believes then, that the first claim upon its attention and assistance is that of maintaining in London and the larger cities effective power houses of opera, music and drama; for unless these quality institutions can be maintained the arts are bound to decline into mediocrity."

Four different strands combined to inform the Arts Council's thinking, and continue to have echoes into the late 1980s. The first, "the trickle down theory", was originally stated by a senior government official in 1805, who wrote that "a drop in the ocean of our

expenditure would sufficiently impregnate the powers of taste, in a country nationally prolific in every department of genius." Or, in the language developed to make the argument 150 years later, funding for a handful of "centres of excellence" would, by unexplained osmosis, enhance the standards of all forms of cultural activity.

The second, and related strand, was the ACGB's already mentioned commitment to professionalism, which stood in marked contrast to the emphasis of CEMA on amateur and do-it-yourself activities in drama and music. During the 1940s and 1950s arts funding gradually shifted away from a strategic and active programme (some members of the Council had originally thought in terms of a national plan for the arts) towards a more reactive stance, with the Council becoming almost exclusively engaged in long-term relationships with dependent, professional bodies.

The third strand, never clearly defined, has to do with the idea that the arts, above all high art, had become the moral and spiritual treasury of the nation. In 1824 the Chancellor of the Exchequer defended public expenditure on works of art as being "consistent with the true dignity of a great nation", an argument that is echoed with each successive battle to "save" another masterpeice for Britain. In the 1980s, Sir John Tooley, Administrator of the Royal Opera House, was seriously able to claim that cuts in the arts would mean "spiritual bankruptcy for the country". From the days of Matthew Arnold onwards the idea that high culture could perform some of the roles vacated by organised religion, through the potential for self-improvement of the individual, has had wide appeal. As with the argument for centres of excellence there seemed to be an underlying assumption that in matters of the spirit, quality would make up for quantity.

The fourth strand, equally hard to define, was a revulsion against money. When Keynes, the founder of the ACGB and the greatest economist of his generation, came to the arts, it was to protect them from the debilitating effects of commerce (although he believed that in time, as the discrimination of the audience improved, the high arts would become self-sufficient). The influence of the Leavisites was also immense, and their Manichean division of culture into mass (commercial, low, often electronic based) and minority (high, usually unmediated by twentieth-century technologies, and provided in the authentic setting of a theatre, concert hall, gallery or library) set the terms of debate which continue to this day.

Funding for the arts has always been shrouded in euphemism and ambiguity. Its overall justification has usually been argued in terms of the educative role of art or, in some versions, in the need to civilise the masses. To admit to a purely pecuniary motivation for producing a

painting or making a sculpture, or to a more overtly social role for art seemed to undermine the very notion of what it meant to be an artist. The Arts Council emerged as much from the tradition of patronage, responsible trusts and charities (CEMA was originally set up by like-minded individuals with private money from the Pilgrim Trust), as from the burgeoning welfare state. To make arguments for the arts in terms of economic effects or employment was seen as vulgar. For both right and left the argument for art depended rather on its opposition to the demands of growth, the economy and Mammon. Hence the need to construct vast edifices of ideology based on the inherent value of art, and its spiritual and moral role.

From Benjamin to Baumol: the work of art in an age of mechanical reproduction?

Throughout the last hundred years new forms of art have continually made the laborious transition from low, mass culture to critical respectability and a place within high, "arts" culture. Film and cinema passed slowly from the fairground sideshow to the arthouse, paperbacks from chapbooks to the tasteful trade paperbacks of the 1980s. As Janet Minnihan has pointed out: "It was entirely characteristic of the bureaucratic response to art in early twentieth-century England that films were regarded first as a potential source of corruption to be policed like the theatre and occasionally the picture galleries." When commercial television first appeared on the horizon, it was compared to the black death and smallpox, while in the 1980s it has become one of the jewels in the crown of British culture. Today, cable, satellite and video threaten to bring the end of civilisation as we know it, but will themselves doubtless undergo much the same transformation. New cultural forms always seem to produce frenetic moral panics (it is of course always easier to recognise an external source of evil than to remove the plank from ones own eye!).

Somehow the Arts Council has remained strangely impervious to the newer, technological art forms, and its chosen fields of activity remain those of the pre-twentieth century – drama, ballet, opera, orchestral music and the visual arts. Film has always been kept at one remove. Photography was only accepted into the canon in the late 1960s, more than a century after its invention. Even literature has never been accepted as a legitimate part of the Council's activity, always regarded as a question of individual talent, and therefore without need of any institutional support.

But in this stance lies one of the ACGB's greatest problems. For these areas were, and still are, subject to an unavoidable economic process, most coherently theorised by the American economist William Baumol. The pre-electronic arts are resistant to increases in productivity – there is no way of reducing the number of parts in the *Merchant of Venice*. So productivity increases in the rest of the economy and the cost of producing soap powder, fish fingers, as well as tapes and newspapers, goes down, as the relative cost of the performing arts goes up. This long-term process has gradually pushed new areas into subsidy. The years before the formation of the Arts Council witnessed the collapse of the British theatre network. At the time of the First World War 206 towns had at least one playhouse and some had many more – Liverpool had twelve and Newcastle and Manchester eight each. After years of competition from the cinema and television, the unsubsidised theatre circuit barely exists outside the West End and the summer seaside circuit. In the same way the successful and flamboyant impressarios of classical music and opera (the very word entrepreneur has its origins in this field) were replaced by quieter administrators familiar with the ways and means of funding bureaucracies.

By concentrating on pre-twentieth century forms the Arts Council has condemned itself to a semi-permanent crisis, both economic and cultural. In financial terms this could be ignored in the bullish, expansionist days of Lord Goodman, less so in the retrenchment of the 1980s.

At the same time the artistic criteria for spending have been increasingly contested. That its cultural daring was manifested in the form of bricks in the Tate Gallery earned it widespread derision, and made it an easy target for stand-up comedians and cartoonists. The *Sun* asked that the ACGB be abolished: ". . . even a penny of public money is too much to spend on this squalid rubbish".

The Arts Council, along with the BBC, thus became a prime focus for the attack on the wet, liberal, mildly traitorous wing of the British ruling class. Both institutions experienced the phenomenon accurately described by Raymond Williams: "As one after another of the stylish old institutions, which had supposed themselves permanently protected, is cut into by the imperative of a harsher phase of the capitalist economy, it is no surprise that there is only bewilderment and outraged pessimism." Management investigations showed that many small Arts Council grants cost more to process than the value of the grant. Having failed to secure real increases in funding with its familiar softly softly approaches through the usual channels, the ACGB went the whole way in 1985 with an annual

report modelled on private industry, under the title "A Great British Success Story".

This report sets out the case for an "increase in public investment in the arts" on the grounds that a small rise would bring "quick and sizeable returns". The report was full of phrases like "the arts have an excellent sales record", and defined their range as including the RSC and Hull Truck, the Royal Ballet and Welsh National Opera, "films like *Gandhi* in the cinema and BBC television's *Bleak House*", playwrights like Tom Stoppard, actors such as Laurence Olivier, poets such as Philip Larkin, musicians such as Simon Rattle, and dancers such as Robert Cohan. Yet there was not a whisper about the popular music industry, which had just completed its most successful year ever, or about pop video, in which Britain led the world, no mention of Britain's role as a servicing centre for films such as *Star Wars* and *Superman*, and no mention of the more innovative areas of television, such as *Spitting Image* or the new soap operas. Nods were made in the direction of ethnic arts, yet the first black face to emerge from the glossy pages was that of Ben Kingsley, made up as Gandhi.

Allusions in the press pointed to the real purpose of this remarkable document. It was, according to reliable leaks, written and designed with only one reader in mind, the infamous scourge of quangos and celebrated critic of the arts bias in British education — Margaret Hilda Thatcher. This explained the language of its conclusion that "money spent from the public purse on the arts is a first rate investment since it buys not only the cultural and educational elements, never more necessary at a time when work and leisure patterns are rapidly changing, *but also a product* with which we compete on equal or superior terms with the rest of the world".

Three individuals had presided over this transition from civic patron to Thatcherite instrument. One was Sir William Rees Mogg, who, as editor of the *Times*, had played a key ideological role in setting the Thatcherite agenda, particularly on economic issues. Mogg unashamedly led the shift away from the arm's length principle, explicitly describing the ACGB as "the state instrument for aiding the living arts". The second was Luke Rittner, who had made his name through the Bath Festival and the Association for Business Sponsorship of the Arts, which had been highly successful in persuading businesses of the virtues of the arts as, in his words, a "civilised vehicle for business activity". The third, an accountant called Anthony Blackstock (the main author of *A Great British Success Story*), obligingly explained: "You have to talk to this government in a language it understands."

In the 1980s sponsorship has become the latest figleaf to obscure

the relationship between art and money. Unfortunately it has had the further effect of obscuring the question of the relationship between minority culture and mass culture. Hitherto most sponsors have seen the arts as a cost-effective means of reaching very narrow, elite audiences, unreachable through more conventional means. Hence the concentration of the oil companies and banks (both of which have been fearful of government interventions through windfall taxes and other regulations) on sponsorship of institutions such as the Royal Opera House. Sponsorship is a fairly ineffective tool for reaching a mass audience (unless there is a particular barrier to overcome such as the ban on television cigarette advertising), but highly effective for reaching people of influence. In this way the bias towards metropolitan centres, and towards relatively unchallenging minority culture, will tend to be strengthened by an expansion of arts sponsorship.

Sponsorship also uses "art" as a cover for some fairly dubious political projects too, as the *Guardian* art critic Waldemar Januszczak has pointed out:

> "Is the relationship between government and sponsors even more complex than we imagine? There is plenty of food for speculation. The arrival on the sponsorship market of the United Technologies Corporation and their subsidiary Sikorsky Helicopters, was paralleled almost exactly by the arrival in Britain of the cruise missiles which they helped design. Making the opening speech at the Anthony Caro exhibition at the Serpentine, which UTC also sponsored, the then Arts Minister, Lord Gowrie, pointed out how splendid it was that the show was a result of private rather than state initiative.
> . . . it became increasingly clear (as a result of the Westland scandal) why Sikorsky and company were so determined to build themselves a good corporate image in Britain. It seems that in such cases cultural sponsorship is part of a softening-up process, forming the vanguard of a larger economic strategy."

Municipal culture: Saturday night at the civic baths

Most discussions of arts and cultural policy assume the pre-eminence of the Arts Council. Yet in fact the Council is only the fourth most important patron of the arts in Britain. First, and by a long way

foremost, are the local authorities, largely through statutory spending on libraries, but which have also, as we shall see, been much more imaginative in other areas. Their spending of £1,300m on leisure and culture is nonetheless described by the ACGB as "a backdrop" to its work. Second comes central government, through its funding for museums and galleries and the British Library. Third is the BBC, which not only spends more on sponsoring arts and artists but also provides them with far larger audiences than the Arts Council.

For local councils, an important legislative step was the Labour government's Local Government Act, 1948, which raised the amount of rates which could be spent on the arts from a penny rate to sixpence worth. These were maximum figures, of course, and no local authorities were obliged to spend any money at all. But, as we shall see, this major revision upwards did at least allow those local councils who took arts seriously a much greater freedom. Even so, a survey of spending on municipal entertainment carried out in 1963, some 15 years after that legislation was passed, revealed that the average net expenditure nationally by local councils was still only about the equivalent of a penny rate.

The 1951 Festival of Britain was in many ways the only popular mass festival organised by a Labour government. The idea for it developed during the war but it was Herbert Morrison, leader of the London County Council, MP and Cabinet Minister, who committed the Labour government to it in 1947, with a budget of some £11 million. It was to be a festival celebrating the end of the war and *an age of reconstruction*. Though Morrison denied it had anything to do with politics, it was nevertheless felt by the majority of people to be a celebration of popular culture, and an expression of a new beginning in civic spending, better and brighter housing, and art for the people. It also established the South Bank as a site for the arts, and in effect helped to boost the morale of that economically poorer part of London on the south side of the Thames.

The Festival of Britain was also a great success. For two or three evenings the police had to close the Embankment to traffic because the crowds walking along by the river were so thick. On one day alone, over 150,000 people attended the Festival, and in an atmosphere of communal celebration which spilled over into many local pubs and cafés, producing spontaneous sing-songs and dances. (Some thirty years later this happened again at the massive GLC festivals on the very same site.) Once again it is interesting to note how much the Tories hated every penny spent on such a "monumental piece of imbecility and iniquity". Two years later the Conservatives spent rather more money organising a counter festival in the form of the 1953 Coronation.

The key word in post-war Labour Party vocabulary was "civic". It expressed the strong sense of active citizenship which came out of the war; it expressed a sense of there being such a thing as a "civic culture" – the reciprocal responsibility between state and citizen, and amongst citizens towards each other. "Civic responsibility" and "civic pride" were transformed physically into "civic halls", "civic baths", "civic gardens", "civic theatres" and so on. "Civics" even became the name of a subject in schools. This is where the heart of such cultural policy as there was at a local government level was expressed: through very patrician forms of municipal provision.

In this era it is significant that the "arts" rarely had a council committee of their own. Such spending as there was generally occurred under the wider remit of committees with such grandiloquent titles as The Municipal Parks, Halls and Baths Committee, or The Committee for Arts, Recreation and Gardens. The 1963 national survey on Municipal Entertainment in England and Wales found that forty-three per cent of expenditure on "entertainment" was on the upkeep of buildings. Out of a total of 535 local authorities who responded to the questionnaire the most popular form of expenditure was on "band concerts", followed by indoor art exhibitions, children's entertainment, ballroom dances and orchestral concerts. Other items listed included bowls tournaments, horticultural shows, lectures and swimming galas, beauty competitions, professional wrestling, football and netball tournaments. Spending on "theatre" came an insignificant fourteenth.

It would be easy to mock this list, but to do so would be to fail to understand the notion of "civic culture". Watching the band in the park on a Sunday afternoon, after a stroll through the municipal rose gardens, was seen as the defence of a civic culture which commercial entertainment threatened. It was the later arrival of a separate and dynamic (and commercial) youth culture which blew this world apart – for it was often because young people felt that local government policies on entertainment and culture had nothing to offer them that they often, literally, rampaged through the municipal gardens, painted graffiti over the bandstands, and played their transistors loudly on the steps of the town hall or public baths.

Labour initiatives

In 1959 the Labour Party produced a new policy statement on the arts, "Leisure for Living". This made no mention at all of the 1945-51 Labour government's complete failure to pursue a cultural policy, which later critics such as Raymond Williams have described as a

catastrophic failure "to fund the Labour movement culturally, when the channels of popular education and popular culture were there in the forties . . . (and which) became a key factor in the very quick disintegration of Labour's position in the fifties". The document praised earlier decisions to fund the re-establishment of "Covent Garden as an opera house of international repute", and went on to argue that "the main concern of those who have public money to spend on music must be with the sort of music that is not usually regarded as popular"! What such a policy actually represents is the re-distribution of wealth from the working classes to subsidise the institutions of the upper classes.

It was a Labour government, however, which first appointed a Minister of the Arts with Cabinet status. This was Jennie Lee, who came into office in 1965. At first she was installed in the Ministry of Public Buildings and Works, as though her main responsibility was the upkeep of listed buildings. However, she moved quite quickly to the Department of Education, in which the Arts Minister was based until a separate Office of Arts and Libraries was formed. A crucial opportunity was still missed to integrate all the different responsibilities for the arts into one single Ministerial brief. Even today, the various aspects of arts, cultural and communications policy are divided between at least five departments.

Possibly the most memorable achievement to come out of Jennie Lee's period of office was the Open University, an innovation which combined a commitment both to enlarging educational opportunity and creating a cultural resource that could be used by anybody. It is interesting that so often Labour's educational policies and its arts policies have been driven by quite opposite philosophies. It is assumed that a radical educational policy implies the ability of all people to develop new skills and abilities, whereas so often its arts policy has simply assumed people's need to learn to appreciate the skills and abilities of others.

As famous in its time was "Centre 42", an initiative by playwright Arnold Wesker to get trade union support for the arts. The name came from a resolution (No. 42) passed at the 1960 TUC conference calling for a much greater trade union involvement in the arts. And for a while a number of concerts and festivals were held, specifically aimed at trade union members although the initiative quickly fizzled out through lack of long-term funding and commitment.

For a while Centre 42 occupied the Round House, a large disused engine shed in Kentish Town, London. It was an ambitious and brave project. But, like so many other Labour initiatives, it was founded on the distribution model of cultural democracy – that the problem

was of taking existing art to the workers, not trying to create new forms of art. Having managed to raise the money to buy the freehold of the Round House, for example, it was announced that the first phase of development would be to convert the building for use as a rehearsal room for three London symphony orchestras! This exactly coincided with The Beatles and the emergence of hundreds of self-taught working-class rock groups making their own music for the first time.

The most recent and comprehensive Labour Party policy statement on the arts, "The Arts and the People", was published in October 1977. Once again, rather than challenge traditional definitions of the arts and forms of cultural production, it simply – and within its terms, convincingly – argued the case for greater democracy in the decision-making processes which governed the allocation of resources, and greater democracy and trade union involvement in the running of the institutions which provided the arts to the people. That is to say it was a strong programme for reform and democratic accountability, but it was not a radical programme for popular cultural democracy.

The major weakness of this approach can be seen in one of the opening remarks in the policy:

> "We maintain that the arts is not a rarified world – approachable only with a university degree, or relevant only to a small, highbrow elite. Rather, the greater works of art in any medium appeal equally to the emotions and the mind of any person prepared to open himself *[sic]* to them."

Well-meaning as this is, it is also nonsense. Sadly it is still the case that complex works of art do not explain themselves like a speaking clock just because the watcher, listener or reader goes to them with all the goodwill in the world she or he can possibly muster. There are many things which stand in between, and which are largely to do with education. That is why it is difficult, and probably impossible, to build a programme of cultural democracy (and to start a programme) from the starting point of "great works of art". "Great works of art" may be where some people want to get eventually, but the starting point is most certainly somewhere else – with peoples' own forms of expression and experience, and how those experiences can be given shape through music, painting, writing, photography, film-making and so on. This is where a radical policy should start.

A second major weakness in the 1977 Labour Party document is that it largely ignores the electronic and commercial forms of culture – recorded music, radio and television, photography, publishing, video – and confines its arguments to the more traditional notions of "art":

theatre, orchestral music, painting, literature and film. It is a radical manifesto for education, aesthetic discrimination and consumption – but not for production.

The same criticism can be levelled at the last TUC report on the arts, which came out a year earlier than the Labour Party document, in 1976. This also argues a case for more public spending, for greater democracy of decision-making by the Arts Council and the Regional Arts Associations, and also highlights the role of education in creating a wider public for the arts. Understandably, though, it gives an even greater emphasis to the needs of professional workers in the arts – in terms of job security, wages and conditions of work – as one would naturally expect from a committee made up of representatives from many of the unions who organise professional artists.

What is not evident in the report is any sense that there may be a conflict of interest between the needs of professional workers and the interests of an active voluntary tradition in the arts. This is also a conflict that has been seen in discussions about radical policies for social work, education and many other aspects of our civic life, and most certainly has to be considered in the field of the arts. For it can be argued that in the period in which the report was written, and even more so since, some of the most exciting examples of radical (and popular) creativity – in new forms of publishing, in pub rock and jazz, in four-track music recording, in community video production – have come from voluntary effort and using forms of production outside the limits of traditionally organised trade union companies and processes.

We would also argue that in the long term this explosion of creativity has led ultimately to more jobs in mainstream printing and publishing, and in the music and video industries. But the connections are by no means as easy to determine (and financially support) as the traditional grant to the professional arts organisation like the civic theatre or symphony orchestra.

Cultural production

These new difficulties – and challenges – are compounded by the increasing segmentation of the production processes within cultural production, in which more and more work is done on a freelance, part-time, sub-contracted basis. To put it crudely, many films and video productions are no longer studio-bound, involving the use of fixed crews, sets, and all the apparatus of regular, serialised production, but are filmed on site using highly mobile equipment and crews. Writers, graphic artists, musicians, camera crew, are now more likely to be

hired on a project basis rather than be part of a fixed set of production workers at a studio. In publishing, many of the smaller new publishing houses – particularly ethnic and feminist, gay and lesbian, publishing perhaps six to twenty titles a year – clearly cannot afford to employ resident designers, proof-readers, copy editors, graphic artists, etc., and buy in these skills on a project basis too. It is also the case that many people involved in such projects prefer to work on a job-share or part-time basis, still having responsibility for child care, or the need to supplement the lower wages of radical or experimental publishing by more lucrative work teaching or working for a large mainstream publisher.

In recorded music this trend is equally evident. New bands hire studios on an hourly basis, often bringing in their own choice of studio engineer as a freelance worker; record pressing and cassette duplication is sub-contracted out, as is label design and so on, particularly in the "independent sector". Such practices inevitably conflict with the aims and philosophy of the trade union movement.

This is one area in which arts policies can learn much from economic policy. One of the most economically successful regions of Europe, for instance, is Emilio-Romagna in Italy, and its economy is in many ways very similar to these parts of the cultural industries. Its key industries, such as ceramics and shoe manufacture, include a high element of design and creative input, and are organised through complex chains of sub-contracting. With the assistance of the regional authority, which is run by the Italian Communist Party, many of these sectors are organised through loose cooperative structures. This ensures that the different companies do not compete with each other on price: they organise joint arrangements with key suppliers and share out work both when there is too much and when there is too little. Common services are provided in such areas as marketing or accountancy where individual companies have neither the resources nor expertise to organise their own. The work often involves very high technology machines, digitally controlled lathes and computer-aided design, but rather then deskilling workers the technologies are often linked to older craft skills.

Assisting the coordination of fragmented sectors, setting up cooperatives of freelance workers and providing common services will also, in the future, be as important to arts policies as the direct subsidy or the guarantee against loss. The Italian experience also shows the impact of an aesthetically literate culture on the economy. Across many sectors, Italian design is famous. As more and more goods are bought for their style, as aesthetics and utility fuse, the cultural quality of goods, cars, toasters, clothes or crockery takes

on an even greater significance. The traditional British policy of competing by cutting costs has been challenged by the Italian experience, which has shown that within the parameters of a modern capitalist economy the most successful strategies often involve enhancing quality and design. Perhaps William Morris is, after all, the key to corporate success.

Britain has also shown some innovation in linking economic and cultural goals, though again the inspiration has come from local authorities and trade unions rather than the traditional institutions. Two notable examples of trade union initiated schemes are the ACTT (Association of Cinematograph, Television and allied Technicians) Workshop Agreement and the same union's Job Fit scheme.

The Workshop Agreement was developed in response to the many radical film and video makers who wanted to be able to operate independently of mainstream studio production, often working with local and campaigning groups, while retaining the right to broadcast on Channel 4. The Agreement also acknowledged that within the recognised workshop, jobs and skills could be interchanged as long as all workers belonged to the trade union (i.e., that it no longer had to be the case that one man directed the film, other male workers acted as camera crew, whilst willing women did the make-up, fetched cigarettes and made the tea). Having established the principle of a union-recognised independent sector, the workshops have grown rapidly, often with funding from local authorities and the British Film Institute. There are now nineteen in operation, including black film groups such as Sankofa and Ceddo, and women's film and video production groups such as the Leeds Animation Workshop and Sheffield Film Coop.

Another innovative scheme which begins to address the gender and racial bias of existing film and broadcasting is the Job Fit scheme, developed by the ACTT with funding from the Greater London Training Board, and supported by the main employers' association. Under the scheme a small levy (0.25%) is paid from all film production budgets into a central fund. This money is then spent on providing short and long training courses particularly aimed at women and ethnic minorities. It is an excellent example of a union using its power progressively to promote access to the industry, and compares very well with the extremely restricted entry to, for example, the BBC's training programme, still the main source of training in broadcasting, and still heavily biased towards Oxbridge.

Linked to the question of job security and professionalism in the arts, it is worth looking briefly at one of the most ambitious state schemes for supporting artists – that which emerged under Roosevelt

in the USA in the early 1930s. Under the Federal Emergency Relief Act of 1933, Federal Writers' Project, the Federal Arts Project, the Federal Theatre Project and other arts related works schemes were spawned. The FERA programme was a crash plan for getting people off the dole, but quite early on it was realised that arts workers also had rights to work. Many artists who later became famous worked on the Federal projects as a means of financial support in their formative years. And out of this project grew what is now known as the "Percentage for Arts" scheme, whereby a fixed percentage – usually one per cent of all new buildings, refurbishment schemes, parks and road projects – is allocated for artistic work associated with that project. Such a scheme is now already established in Seattle (USA) and similar schemes work with varying degrees of success in Norway, Italy, Finland, the Netherlands and Canada. Since it was recommended in the 1977 Labour Party policy document, we would also argue for its retention as an important element in a radical visual arts policy, though we think that the concept of the visual arts should be open to as wide a definition as possible, and most certainly include the practices of design, style, the quality of commercial graphics, as well as the more traditional forms such as paintings, sculptures and prints.

The Federal Writers' Project put over a thousand writers on to government payrolls, and engendered some of the most important oral history and folklore collecting work ever to be done in the USA. Writers were commissioned to collect folk tales, songs, histories of local social and religious movements, as well as many hundreds of slave testimonies, which later formed an indispensable archive for black historians. Fortunately much of this kind of work is now being done in Britain by local history workshops and local publishing projects such as Bristol Broadsides, Stepney Books, Centerprise in Hackney, the Merseyside Writers Association, Yorkshire Arts Circus, Queenspark Project in Brighton, the Bolton Oral History Project, Commonword in Manchester, the Television History Workshop, the annual History Workshop conference, ethnic publishers such as Akira Press, Bogle L'Ouverture and New Beacon Books in London, and many other popular memory and local history projects. Support for this reconstruction of local and national popular histories should be an important element in a radical arts policy. It is likely that local and regional museums will become much more engaged with this kind of "history from below" in future, and many more jobs could be secured for people interested in history and writing through enterprising museum and local publishing projects, many of which would earn a large proportion of their revenue needs

through sales.

Many local authorities have now begun to support such projects, and doing so has meant that old reservations about socialistic support for arts projects which engage in trading are being overcome. Yet for many years linking arts policy with economic development would have been anathema. Now it is in some spheres of popular culture the most sensible way forward. In the same way that no responsible local authority could possibly allow the disappearance of such important social facilities as post offices or bus services without a fight, today many realise that in order to keep bookshops, record shops, recording studios, dance halls and other music venues, local government support is needed.

In the immediate future it seems unavoidable to us that local authorities will be key agencies in local and regional mixed economies. This is what pioneering local authorities such as Tyne and Wear, Sheffield, Manchester, Hackney, Southwark, Nottingham, Islington,the GLC, and a number of others have realised and begun to act upon. It is imperative that more financial and administrative resources are made available for local economic development in the new cultural industries. A failure to engage with the new forms now will once again leave all the initiatives and power in the hands of the commercial market, and the devil will continue to have all the best tunes.

Chapter 3

The state and broadcasting: missionaries and mercenaries

"As ambitious a bunch of mercenaries as ever held up a gravy train."

(Jeremy Isaacs on the proponents of deregulation in Broadcasting)

Television and radio occupy a dominant position in British culture. Watching television takes up over a third of people's free time, and the average British adult watches over thirty hours each week; ninety-eight per cent of all households have a set, one in five in their bedrooms, and fourteen per cent of households have sets in their child's bedroom. Broadcasting also dominates other sectors of cultural activity, whether through the playlist of records on radio, the screening of pop videos or through operas and other arts programmes. And while broadcasting is notoriously parasitic, feeding off currents of innovation in film, in theatre or in comedy, it is also the single most significant patron of the arts in Britain. According to the House of Commons Select Committee on Education, Science and the Arts, in 1981/2 broadcasting institutions spent £197 million on a comparatively narrow definition of culture (drama, serious music, etc.). This compared with the Arts Council's budget of just £74.7 million in the same year.

For the consumer, broadcasting – from the purchase or rental of a set through to a licence fee, and more recently cable and satellite subscriptions – accounts for far more spending than parallel sectors such as the press or publishing. An audience the size of a Cup Final crowd warrants a zero rating on television. As Trevor Griffith wrote in another context: "There are fewer cinema goers in Britain now than there are anglers; fewer regular theatregoers than car rallyers . . . but a play on television will make contact with anything from three to twelve million people." Though more films are seen than ever before this is largely on television or video. Cinema audiences have fallen to around one-fiftieth of their war-time peak.

Broadcasting is also the one twentieth-century cultural form in which the British state has taken an active role, and therefore exemplifies all the problems of straightforward nationalisation. The history of the state's involvement in broadcasting shows all too clearly the problems of contrasting a (socialist) public sector and a (capitalist) private sector. Today broadcasting is the central battleground between competing visions of public service and free market deregulation. On the right, the Peacock report has brought out the fundamental contradictions between free market libertarians and old Tory paternalism. On the left, a long overdue debate about the limits of public service and statist models has been precipitated. This chapter looks at the difficult history of broadcasting as a state-sponsored form.

When the BBC was granted a licensed monopoly in the 1920s, it continued a long tradition of state control. In theatre, the state licensing system had deep roots dating from the time of the seventeenth-century patent theatres, when the state licensed certain forms of culture and rendered other forms illegitimate. In the case of theatre most popular forms – including musical comedy, farce, revue and later music hall and light opera – were illegitimate, and open to prosecution by the Lord Chamberlain. In the press, from the time of the Star Chamber, a parallel history of controls, suppression, licensing and taxation created duel media, and a mass circulation, radical, illegal press whose circulation often well exceeded that of its legal counterpart.

Film too, in its early days was subject to the full paraphernalia of control. The British Board of Film Censors, established to take over the local authorities' licensing role banned all films which depicted strikes or labour unrest (including Russian films such as *Battleship Potemkin*), films that might upset religious groups (which led to a ban on a biography of Martin Luther) and all films that might offend friendly countries (a rule that meant that no films were shown before 1939 that could be construed as critical of the Nazis – in films such as Hitchcock's *Thirty Nine Steps* the Nazis are portrayed as murky Central Europeans). Walter Greenwood's *Love on the Dole* was considered too radical and got no further than the script stage until the Second World War ushered in a more liberal climate. Sir Edward Short, the first president of the British Film Board of Censors, had previously been appointed by Lloyd George for his expertise in counter-subversion to deal with the Bolshevik threat.

In film an active counter culture, outside the scope of the BBFC, was developed by the labour movement through organisations such as the Workers Film Society, the Workers Film and Photographic League, the Socialist Film Society and Kino, which sought to develop

an authentic, realist working-class film movement to counter the power of Hollywood. While still relatively marginal, in one year, 1936, Kino reached an audience of nearly 250,000 people through over 1,000 separate screenings.

In more recent times broadcasting has generated its own version of this struggle in the battle between a myriad network of pirate radio stations – from Caroline through Invicta to the Dread Broadcasting Corporation (and now Network 21, the first pirate television station in the UK) – and the penal fines and appropriations of the latterday Lord Chamberlains of the Department of Trade and Industry.

The BBC and Reith

The pioneer of state broadcasting in the UK was John Reith, a man who, in the words of historian A. J. P. Taylor, used the "brute force of monopoly to stamp Christian morality on the British people". The BBC was granted its monopoly at a time when the British cultural elite saw its position undermined by the seemingly unstoppable flow of American popular culture. Hollywood, Tin Pan Alley, cheap American fiction and the advertising techniques of Madison Avenue threatened the great English cultural traditions represented by Matthew Arnold, and assiduously re-stated by F. R. Leavis – who both believed that culture (and particularly "Literature") should take on its shoulders the moral and spiritual improvement of the people.

The American experience of broadcasting according to Reith had brought "no coordination, no standard and no guiding policy". To the then popular solution of the public corporation, the BBC, originally a consortium of private radio manufacturers, therefore added the status of a Royal Charter, with a board made up of the "cultured great and the good". Appointed by the state, the board would be independent in its operations, and as a model it was to be followed twenty years later with the Arts Council. Its actual relation to the state was soon tested in the General Strike of 1926 when Reith, famously, argued that "since the BBC was a national institution, and since the Government in the crisis were acting for the people . . . the BBC was for the Government". The "arm's-length " principle exemplified the ability of the British ruling class to universalise its own perspective and interests, and then go on to define them as being natural and common-sense interests beyond mere "politics".

The model adopted for state intervention in broadcasting is, however, paradoxical. On the one hand the government took, and retains, massive powers. It appoints (and can dismiss at any time) all

the members of the BBC and IBA. All the present BBC Governors have been appointed by Mrs Thatcher. They can demand the transmission or non-transmission of any programme. But at the same time the practice of regulation has been relatively relaxed. The draconian powers are almost never exercised. The system runs smoothly on the assumption of shared cultural and moral values.

When the *Real Lives* programme on Northern Ireland was ineptly suppressed in the spring of 1985 by the then Home Secretary, Leon Brittan, for example, Lord Annan revealed the underlying logic of the system when he berated the government for dealing with the BBC Governors in public rather than having a "quiet word" with them. The BBC too has been concerned enough for its own survival to abide by the rules. As former Arts Minister Hugh Jenkins wrote: "Their role was to be independent inside the aviary, to fly about freely but not to question the shape of the cage and, preferably, not to be aware of its existence."

The BBC under Reith was fundamentally about moral and cultural improvement. Mere entertainment and diversion came low on the list of priorities. In the 1930s the BBC's response to public complaints that it did not broadcast enough popular music was to play more classical music. Given sufficient exposure, the public would soon come to appreciate the inherent superiority of "serious" music, it was argued. Popular music "doesn't wear . . . whereas good music lasts, mellows and gains fresh beauties at every hearing. It stands like Shakespeare, through the centuries." As Reith argued: "The BBC must lead, not follow, its listeners, but it must not lead at so great a distance as to shake off pursuit."

Reith also laid down a similar guiding principle when he wrote that "few know what they want and very few what they need". This maxim was reflected in his opposition to any form of audience research which would encourage programme controllers to "pander" to popular taste. Reith's attitude didn't endear him to Labour politicians. George Lansbury said that "he would have made a very excellent Hitler in this country".

Culturally the BBC was caught in a series of paradoxes. It saw itself as a leading agent of cultural enlightenment against the forces of darkness of the American cultural industries; yet broadcasting was sneered at by the British cultural elite. Those who ran the BBC stood against commerce, yet found themselves in charge of a genuinely mass medium that was restructuring other areas, most notably the popular music industry (witness the change from the publisher/showman/song system to a record company-based star system largely dependent on the programme policies of the BBC), and which was developing as a powerful tool of capitalist marketing and

consumerism.

For the first twenty years of its existence no spontaneous speech, and almost no "regional" voices, were permitted on the BBC. D. G. Bridson, who pioneered the use of regional voices in *Harry Hopeful's Northern Tours* (described in the BBC's Yearbook as a series of interviews with "peasants from remote northern districts") wrote that "since its inception the BBC has been the exclusive concern of 'us' and listening the lucky privilege of 'them'. That the man in the street should have anything vital to contribute to broadcasting was an idea slow to gain acceptance. That he should actually use broadcasting to express his own opinions in his own unvarnished words was regarded as almost the end of all good social order". As recently as 1981, the latest edition of a BBC staff pamphlet "The Spoken Word" began: "In what follows it is assumed that the speaker uses Received Standard English in its 1980s form. The form of speech recommended is that of the person born and brought up in one of the Home Counties, educated at one of the established Southern universities, and not so set in his *[sic]* ways that all linguistic change is regarded as unacceptable." The voice of the people, which the BBC could have been, was instead the voice of Oxbridge.

The dangers inherent in these principles were all too apparent during the early days of the war, when senior administrators and politicians became seriously concerned at the low level of civilian and military morale. After a decade of depression and Tory rule it was perhaps unsurprising that the working class should be less then enthusiastic about another war. A 1939 BBC survey showed that thirty per cent of listeners regularly listened to Lord Haw-Haw (the man with the dubious honour of being the first pirate broadcaster to be hanged). A Ministry of Information Committee noted that "something might be done to diminish the present predominance of the cultured voice upon the wireless". But in addition to the cultural alienation of many working-class listeners from the BBC there was also widespread scepticism in 1939 and 1940 about the veracity of its news reports. The BBC faced a profound conflict between its sense of national, cultural mission and the need to boost morale for the truly mass audience it was reaching for the first time.

To revamp the corporation (and perhaps in retrospect as part of the historic compromise with Labour forged in the early years of the war) greater emphasis was given to more popular forms of entertainment. Programmes such as *ITMA* (with the infamous Mrs Mopp) came on the air, mining a rich vein of everyday humour and irony, while both the singing of Vera Lynn (despite the concern of the Governors – "how can men fit themselves for battle with such debilitating tunes in their ears?") and the earnest – and left-leaning –

discussions of the *Brains Trust* all reached huge audiences. Yet despite these moves towards a more responsive broadcasting, the BBC was half-hearted in its desire for change. The huge worldwide reputation it held at the end of the war enabled it to rest on its laurels. When Beveridge, the architect of the welfare state, investigated broadcasting in 1951 he berated the BBC as "beginning with Londonisation, going on to secretiveness and self-satisfaction and ending up with a dangerous sense of mission becoming a divine right".

Smallpox and bubonic plague

"[Since] competition in broadcasting must in the long run descend to a fight for the greatest number of listeners, it would be the lower forms of mass appetite which would be more and more catered for."

(BBC evidence to Beveridge 1949)

Although the BBC had always faced competition – from the continental radio stations outside the reach of government licence, such as Normandie and Luxembourg, and the American PX stations during the war – the introduction of commercial television in 1955 represented the first sustained threat to its monopoly. Reith saw the introduction of commercial broadcasting as akin to the introduction of "dog racing, smallpox and the bubonic plague". There was particular indignation at reports that in the USA, the Coronation had been shown intercut with shots of NBC's television chimp J. Fred Muggs drinking tea. On the very night that commercial television began broadcasting, the BBC arranged to have the much-loved Gwen Archer of the radio series *The Archers* burnt to death in her home, thus stealing the thunder from their new rivals.

The political lines of division around the debate are revealing. For while the key advocates of commercial television were business interests allied to the Conservative Party, the Popular Television Association, which campaigned for an end to the monopoly, included amongst its members A. J. P. Taylor and Canon Collins. The latter was soon to play a leading role in the formation of CND. For many, any diminution in the power of the BBC, and the establishment of which it was a part, represented a step forward for democracy. But on the side of the BBC stood a phalanx of establishment support, ranging from Lord Reith, through Lord Halifax and Lady Bonham Carter to Tom O'Brien, then Chairman of the TUC. Labour promised to abolish commercial television when it came back to power. Polls,

however, showed that Labour voters were considerably more supportive of commercial television than their Liberal and Conservative counterparts.

When competition did reach the airways, the BBC found its audiences deserting in droves, at least amongst those with two channel sets. As critic Peter Black wrote: "Once they had the choice the working-class audience left the BBC at a pace that suggested ill-will was more deeply entrenched than good". In the 1980s the class difference remains. According to "Social Trends 1985", satisfaction with independent television and radio is nineteen per cent higher than satisfaction with the BBC in social classes four and five, a difference that disappears in social classes one and two. Among Labour voters fifteen per cent are more satisfied with commercial broadcasting.

After a brief flirtation with BBC-style programming, ITV began to experiment with new forms much more clearly based in the traditions of working-class popular culture – with melodrama and soap operas like *Coronation Street*, innovative drama such as Sydney Newman's *Armchair Theatre*, addressed to the "marvellous world of the ordinary", comedians with regional voices and the whole tradition of Variety. Its presenters were less stuffy and more irreverent. Its news reporters, like Robin Day, punctured the pretensions of those they reported. Somehow the BBC, a supposedly public institution, had, by its refusal to engage with traditions other than those of the Southern ruling class, left vacant a vast cultural space which the Grades and Thomsons were only too happy to fill.

The BBC soon found that it neglected this space at its peril. Ministers began to question the legitimacy of the licence fee as audiences slumped below thirty per cent. Starting with imitation (Sydney Newman, for example, was poached from ITV and *Armchair Theatre* became the *Wednesday Play*) the BBC under Hugh Greene gradually developed its own distinctive creative identity during the 1960s. Under the liberally progressive Greene regime programmes like *That was the Week that Was* and *Tonight*, and plays like *Up the Junction* and *Cathy Come Home* attracted a whole generation of scriptwriters, producers and cultural bureaucrats to the idea that a public institution could, despite its history, play a role in the vanguard of social and cultural change.

Unfortunately history repeated itself when the manifest failure of the BBC to come to terms with the new youth culture of the 1950s and 1960s created a gap that was soon filled by others, in this case pirate radio. Within a few months of Radio Caroline coming on the air with Simon Dee in 1964 it had reached a reputed audience of seven million listeners for its diet of non-stop pop and rock. But the heyday of the pirates lasted just three years until Harold Wilson's government

effectively killed them off with the Marine Offences Act. Radio Caroline broadcast denunciations of Wilson every hour.

In September 1967 BBC Radio One was born and the first voice to be heard was that of Tony Blackburn, former Radio Luxembourg and pirate DJ. Again the BBC had learnt that if you can't beat them, buy them. This policy has remained operative. More recently the success of the pirate DBC (Dread Broadcasting Corporation) prompted the BBC to buy up one of their top DJs, Miss P.

With the replacement of Hugh Greene by Charles Curran and the appointment of the Tory Lord Hill as Chairman of the Governors, the mild tide of progress turned. One of Hill's first acts was to foreclose the immensely successful, but controversial series *Till Death Us Do Part*. Throughout the 1970s the cultural climate chilled in tandem with a broader retreat into conservatism. Programmes such as Dennis Potter's *Brimstone and Treacle*, Roy Minton's *Scum* and Ian McEwan's *Solid Geometry* were banned, and politically contentious plays like *Days of Hope* and G. F. Newmans *Law and Order* brought howls of protest from increasingly well organised right-wing lobbies. The bright sparks of the early 1960s had become cautious organisation men.

Alongside the climate of cultural and political caution, economic factors also took their toll on British television. As production costs escalated faster than either licence fee or advertising revenue, the demands of export markets or co-producers permeated the story lines of British series and dramas. From the *Forsyte Saga* and *The Six Wives of Henry the Eighth* through *Brideshead Revisited* to the *Jewel in the Crown*, a nostalgic, tourist board view of Britain and the British proved the most viable. Similarly, Japan has found a mythic past of shoguns and samurai most lucrative.

Exports and co-productions are becoming economically significant. Earnings from film and television now represent 2.8 per cent of exports from the financial and "other services" sector, and showed a surplus of £131 million in 1984. The USA remains by far the most important market, accounting (along with Canada) for fifty-six per cent of exports and seventy-one per cent of imports. Thames, for example, made $19 million from US syndications of *Three's Company* in 1984 because it was based on the *Man about the House* format, and $15 million in the same year from direct sales of the *Benny Hill* show. US influence means that pre-sales purchasers can now directly dictate script changes and casting on programmes such as LWTs *Dempsey and Makepeace*. Through this process the audience, now international, required for a production to be viable has increased further. The trade is not, however, one way for all the denunciations of cheap, dumped US programmes. Rather Britain is, in the words of

one commentator, the cadet of US television imperialism. This role extends well beyond the sanitised international co-productions that have become familiar to the world's screens. Many of the most successful programmes, such as *Minder* and the *Sweeny* produced by the Thames subsidiary Euston Films, have been successful in overseas markets for the opposite reason: their ability to convey an authentic sense of the people, language, and rights and wrongs of a real locality.

Television and the film industry

The internationalism of the broadcasting economy reflects the experience of the British film industry, which ever since the 1920s has been dominated by Hollywood. This has provided Britain with a lucrative role – films like *Star Wars* and *Superman* (made in Britain using British technicians) are as much British films as *Absolute Beginners* or *Chariots of Fire* – but has also impeded the development of the kind of independent film culture enjoyed by France, Germany, Sweden and Italy. When protection of the industry began in 1927 it was opposed by the Labour Party on the grounds that it would mean more Tory British films and fewer classless American films for the largely working-class audience. Throughout the 1920s and 1930s British film makers, like Reith in broadcasting, gave up on the working class and produced for a middle-class audience. After 1927 Labour tended to go along with the workers' argument that their employment depended on forms of protection – usually quantitative controls on labour inputs, numbers of overseas films shown in the UK. But since the industry had become inextricably linked to Hollywood each protectionist measure was, without exception, circumvented, most famously in the case of the "quota quickie", often shown in the mornings to empty cinemas. The government was no match for Hollywood.

Public funding bodies – most notably the National Film Finance Corporation set up by Harold Wilson in 1949, whose first major investment was in *The Third Man* – often found themselves forced simply to bear risk, providing "end-money" for commercial financiers and distributors who were able to construct deals that ensured they were the first to be rewarded. Ostensibly British films (not unlike the "British" cars produced by General Motors or Ford to qualify for regional grants and subsidies) with American stars and producers also became eligible for Eady levy funds, a tax levied on all films shown in the UK and redistributed to films made in the UK. Policies for cultural independence were often in practice used to reinforce

dependence.

The industry in fact remains dominated by the same companies whose logos covered the screens of the 1930s – MGM, Twentieth Century Fox, Warners, Columbia, Universal and United Artists. The big difference is that even more than before these now form part of much wider conglomerates, usually with close ties to television, cable and satellite companies. Columbia, which recently appointed David Puttnam as head of production, is now owned by Coca-Cola, whilst Twentieth Century Fox has been bought by Rupert Murdoch's News Corporation to provide a ready back catalogue and production facilities for his audacious bid to establish a fourth US television network through MetroMedia and for his satellite channels.

In other countries the close relationship between film and television has been a strength. In Germany the new cinema of Fassbinder, Herzog and Schloendorff depended as much on television finance as on very generous direct state subsidies, while in Italy the best known films by directors such as the Taviani brothers and Franco Rosi were financed by RAI, the state broadcaster. In recent years Channel 4 has begun to pick up this role in Britain. Between 1972 and 1982 the number of films made in Britain had fallen from 103 to twenty-four, but Channel 4 was committed to producing up to twenty new films each year, often on relatively low budgets. The artistic and commercial success of films such as *The Ploughman's Lunch, The Draughtsman's Contract* and *My Beautiful Laundrette* revealed just how unambitious British film making had become, suffocated by the grip of the two big companies which had long dominated British cinema – Rank and ABC – and which had presided over a history of collapsing cinemas and collapsing investment in production.

The blurring of the traditional divisions between different media is causing huge problems for the old institutions. The BBC's natural reflex has been to become involved in any new area of broadcasting, whether breakfast television or DBS, to pre-empt opposition. As a result, and particularly since the birth of Channel 4, its distinctive public service role has become more hard to define. A key moment occurred when the BBC showed the *Thorn Birds*, a soapy television mini-series, starring Richard Chamberlain and Rachel Ward, costing around £600,000, at the same time as ITV showed Granada's *Jewel in the Crown*, whose nostalgic evocation of the twilight of the empire summed up for many the very pinnacle of what public service broadcasting should be (indeed most viewers, when surveyed, thought it had been on BBC). Although the *Thorn Birds* won BBC1 its highest ratings for two years, the widely reported displeasure of the wife of the minister in charge of broadcasting, Douglas Hurd, took on a special

significance as the BBC was then negotiating for a substantial increase in the licence fee.

New challenges

While television has appeared in cautious retreat from its braver frontiers a much more fundamental reappraisal has been under way about the right of the BBC, and broadcasters in general, to monopolise the public space of the airwaves. Agitation around the manipulation of news from Ulster, over industrial relations (from the power workers' strike of 1970 to the miners' strike of 1984/5), the work of the Glasgow Media Group, campaigns amongst media workers over the right to reply and the formation of the Campaign for Press and Broadcasting Freedom, formed part of a process whereby workers in broadcasting began to question the idea that their relation with the audience had to be mediated through the institutional and political constraints imposed by management and Governors and by a murky concept of the public interest. The key movements of the late 1970s and 1980s – the development of the franchised workshops by the film and television union ACTT, the formation of Channel 4 as an outlet for independent productions, and the movements around pirate and community radio – have also brought radical cultural workers face to face with the needs and demands of the audience and with the limitations of "productionist" ideas and the sovereignty of the artist.

During the early 1970s a new coalition of broadcasting workers (seeking independence either to make money or follow their creative conscience), journalists, academics and people on the outside seeking access to the system began to argue for a fourth channel outside the control of either the BBC or the IBA. The various groups which coalesced in the Channel 4 group found an audience in the committee originally set up by Harold Wilson at the very end of the 1964-70 government and re-established when Labour returned to power in 1974.

Chaired by Lord Annan, this inquiry was established to look into the future of British broadcasting, with particular reference to the allocation of the vacant fourth channel. Annan was much more aware than his predecessor, Pilkington, of the limitations of the BBC ethos. In the final report published in 1977 he wrote: "For the individual life is a gamble, he is entitled to stake everything if he desires on one interpretation of life. But broadcasting organisations have to back the field, and put their money on all the leading horses which line up at the starting gate." Pluralism – a system geared to many different publics –

would have to replace the paternalistic assumption of the BBC elite that the world could be defined in their image.

Amongst a range of different recommendations, Annan argued that the fourth channel should be under the control of an independent "Open Broadcasting Authority", funded from a range of sources. The new channel would open itself up both to a new way of organising – acting as a publisher of a variety of voices, rather than as a monolithic institution – and to new audiences. Notions of balance would be redefined to enable it to present minority and explicitly subject views. The ethos of public service would be gradually metamorphosed into service of a variety of publics, particularly those which had been ignored by existing broadcasting – ethnic minorities, specialist sports fans, regional and linguistic minorities. The channel was to be committed to "innovation and experiment".

Yet for all the erudition and weight of Annan's report published in 1977, it came up with what was probably an unworkable formula. The long-term economic pressures on broadcasting were virtually ignored. The impact of new technologies such as cable and satellite were written off as being unlikely to have any impact for at least fifteen years. And while it had much to commend it in terms of its social and cultural perspicacity, the report's economic weaknesses were fundamental.

Following the line of the 1979 Conservative government, the model of an Open Broadcasting Authority funded from a variety of sources was turned into Channel 4 – a subsidiary of the IBA, with a considerable proportion of independent production as in the original model, but funded via the ITV companies, which retained their monopoly of advertising sales. Thus while being a substantial step forward, in institutional terms the birth of Channel 4 represented a partial victory of the institutions over the outsiders. The model did, however, have the advantage of realism. If Labour had won the 1979 election and implemented Annan's proposals there can be little doubt that the Channel would have collapsed, financially incapable of sustaining its cultural and social remit.

What Channel 4 has done is to prove the virtue of a broader definition of public service. In effect it is subsidised from the advertising revenues of the ITV companies; minority audiences are subsidised by mass audiences. And through the tight regulation afforded by the Channel's charter and board, these funds can be directed into programming which would be inconceivable either in the BBC or in a purely commercial framework. Although the independent producers (who provide about a quarter of its programming) may not fit the original vision (twelve of the 300 independent companies produce about half of all the material: many are now multi-million

pound operations) the channel does continue to fulfil much of its envisaged role. It caters for sectional interests, from trade unionists to American football enthusiasts; it is open to new voices, through programmes like *People to People* and *Right to Reply*; it is more internationalist than the other channels and more open to a diversity of viewpoints.

For all its teething troubles and insecurities the channel has also shown how independent companies can be used within a regulated framework. Over 4,000 new jobs were created in production companies, facilities houses and ancillary areas. The innovation and dynamism of programmes such as *Brookside*, *The Tube*, and *No Problem* have also had a substantial impact on other broadcasters, most notably through the BBC's creation of the massively successful *EastEnders*.

Ruling the airwaves

"When Los Angeles can support more than twenty-four radio stations and the Greater Paris area fifty-four stations, the argument that the current system is the only way forward for allocating broadcasting frequencies appears suspect."
(Adam Smith Institute,
Omega Report on Communications Policy.)

"Radio must be transformed from a medium of distribution into one of communication . . . a vast channelling system . . . if it could not only broadcast but receive, not only get its audience to listen but get them to speak out, not to isolate its members but put them in contact with one another . . ."
(Bertolt Brecht).

The control of the government over radio airwaves has always been contested vigorously.

From the days of Radio Paris and Normandie through to Caroline and Invicta, the pirates have been as varied as their motives – from Dread Broadcasting Corporation, a black music station based in West London, to purely commercial outfits such as Laser (rumoured to have been funded by the CIA), eager to exploit the pirates' ability to avoid heavy payments to the Independent Broadcasting Authority and the Performing Rights Society, to overtly political stations such as Sheffield Peace Radio and Radio Free Derry. Radio is also a very flexible medium, and its flexibility can be highly subversive. Stations

have been set up for less than fifty pounds. During the 1984/5 miners' strike, for example, Radio Trent, an ILR station, had its broadcasts interrupted by the militantly pro-strike Radio Arthur. During the riots of 1981 and 1985 CB radios were widely used. During the autonomista "uprising" in Bologna, Radio Alice played a key role (and was finally closed down for its efforts). One of the main reasons for the sudden shelving of the community radio experiment was the Home Office fear that stations would be used to foment riots.

To bring radio under firmer control the Thatcher government pursued what seemed to be a classic strategy of incorporation, in the form of the "community radio experiment". But the "quid pro quo" on the offer of twenty-four two-year experimental licences for neighbourhood and community interest stations was tight control: very weak transmitters with very limited geographical range (the total transmitter power of the whole experiment is less than that of BBC Radio London), restrictions on overtly political or religious stations, subjection to the new Public Order Act and the absence of any financial support or, as significantly, any restrictions on cross-ownership from other media interests. Despite this, a vast range of different groups applied for licences, ranging from pirate music enthusiasts to the relatively straight commercial approach of former pirates Radio Jackie to linguistic and ethnic minorities. However, in the spring of 1986 the government stopped the "experiment" before it had even started.

But while the far left and anarchist groups have seen pirate radio as a chance to create a means of communication far superior to selling a newspaper at factory gates or dole offices, the Labour Party has carefully kept its distance. On the one hand its position has been dominated by the media unions – NUJ, BETA, ACTT and MU – which have experienced job losses at ILR and seen any extension of radio as a recipe for further cuts. At the same time, arguments against deregulation, meaning the removal of public controls, have become confused with the view that there is no space for any extension in the licensed media, whether DBS or community radio, on the grounds that neither licence fees nor advertising revenues could sustain them.

Part of the problem lies in the degree of incorporation of the Labour Party into the British establishment. Because it has identified with public service BBC (despite years of BBC bias against Labour) the party has never understood the importance of independent means of communication. This marks it off from most other European countries, whose socialist parties have experienced suppression and repression. In France, for example, the Socialist Party, despite its own role in establishing the state's monopoly in the 1940s and 1950s,

set up its own pirate radio station, Radio Riposte, in 1979. Boosted by François Mitterand's own involvement in a court case over the party's illegal broadcasts, support for freeing the airwaves from the dead hand of state control was a popular campaign theme in the 1981 election.

The Mitterand government in fact came to power committed to a range of measures to democratise, liberalise and decentralise the media. Yet within a couple of years it faced widespread disillusion. A few faces changed at the top and a new body, the Haute Autorité Audio-Visuel, mediated between government and broadcasters. But the free radio movement was pulled first into the bureaucratic requirements of the state, and second into vulnerability to commercial interests, and in the process lost its political, challenging edge.

The experience of the French radio experiment bears many similarities to the weaknesses of the left and Annan's approaches to Channel 4. Luckily in the case of Channel 4 they were never realised. In France, however, the economic illiteracy of the cultural activists has had unfortunate consequences. Inadequate consideration was given to the economic base of the licensed stations and of how their independence could be sustained. This meant that many were forced into dependence on richer, existing media companies and that the cultural and political goals which inspired the movement in the first place have been gradually jettisoned in favour of round the clock Anglo-American top forty music. Most of the really innovative and radical radio stations have gone bust. Meanwhile, the more commercial stations are using legal loopholes to create nationally networked programmes.

The failure of the French experience is both a warning and a lesson. It is a lesson about how difficult it is for a state to give away freedoms without redefining them in its own terms. And it shows again that culture and economics go hand in hand. For all the momentum and dynamism of the movement to free the airwaves, basic economic forces soon prevailed. Without a coherent strategy for economic support to genuinely local stations and stations serving different needs the passage to homogeneous programming was inevitable.

The experience also shows that under a socialist policy regulation needs to be much more than a means for government simply to award licenses or exercise powers of censorious control. Properly conceived, regulatory bodies should be responsible for maintaining diversity against the profound pressures towards monopoly that operate throughout the communications industries. This means being prepared to fund the long-term development of the sector as well as awarding licences, and acting decisively to withdraw licences when promises are not met.

Licensing bodies of this kind should also be able to support new forms of social ownership in broadcasting – with worker cooperatives and structures that link the interests of listeners, those who use access facilities and the full-time employees. A government with vision would see in such a sector the opportunity to create a strong and independent force in the media, independent both from the media conglomerates and from the vagaries of political change at a national level. What the present British government fears – that community radio might be genuinely independent and outspoken – is precisely its greatest strength.

The free and community radio movements, for all their contradictions and weaknesses, are not going to go away. The crucial question now is whether they will see more opportunities under the deregulating right than under a socialist government. This would be a disaster. Alongside their counterparts in the independent music or publishing sector, they share ideological opposition both to state bureaucracy and to the reduction of broadcasting to the sale of an audience to advertisers. Where they have a commitment to a community, to working in a cooperative organisation for love as much as money, they represent the very best in a socialist culture. Hitherto, however, most have seen more opportunities either in living outside the law or total deregulation than in the doubtful benevolence of a socialist government.

The great and the good

British broadcasting has effectively been kept under the benevolent gaze of "the great and the good". And the great are not always either very great, very good, or, more to the point, very neutral. The most recent Chairman of the BBC, Stuart Young, was a brother of a cabinet minister and the Vice-Chairman, Sir William Rees Mogg, is a well known Thatcherite as well as being Chairman of the Arts Council.

As a creature of state licence, broadcasting has been subjected to a series of investigations by committees of the great and the good, the most recent being the Peacock Committee (whose membership included Sam Brittan, brother of the then Home Secretary). In retrospect these investigations are interesting more for the light they throw on the changing attitudes of the British establishment than for their lasting impact on British broadcasting. As with Lord Annan's report, his predecessors' recommendations were either ignored or turned upside down. Beveridge, despite his criticisms of the BBC, recommended a maintenance of the monopoly only four years before ITV came on the air. Pilkington in the early 1960s endorsed the BBC's

existing popular music policy only a few years before the irresistible pressure of the pirates finally forced the BBC to set up Radio One. In the same way we can probably anticipate that Professor Peacock's recommendations will be of largely academic interest, since before the report was published the government had already dismissed it. Far more significant will be the immediate concerns and interests of the government.

The future of broadcasting is in practice increasingly shaped outside the scope of either government or such enquiries. Part of the problem lies in the fact that broadcasting still comes under the control of the Home Office, lumped alongside security, censorship, counter-subversion and policing. It is small wonder that the present government has shown a lamentable inability to develop a coherent media policy. Over cable, for example, the Department of Trade and Industry sought a free market approach for industrial reasons, while the Home Office was mainly concerned with how content would be controlled. In the end, the quite separate decision of the Treasury to phase out capital allowances torpedoed the goals of both. The scuppering of the community radio experiment by the Home Office, ever-fearful of letting slip its powers of control, is an even more telling example of the muddled and contradictory approach.

The effect of government incompetence has been to give the lead to commercial competition – to Rupert Murdoch's Sky Channel, Italy's Berlusconi and France's TFD-1 satellite project, or on a smaller scale the commercial pirates like Laser. The absence of a policy is itself a policy. More fundamentally, broadcasting is being subsumed under the larger information technology nexus. Investments in Direct Broadcasting Satellites (DBS), for example, are strongly influenced by the battle to control data flows, closed systems for multinationals and facsimile transmission capabilities. In Britain, one of the strongest selling points for cable companies is access, via Mercury, to a cheaper telephone service. With both cable and DBS, some view broadcasting as little more than a loss leader to connect enough homes and businesses for the really profitable communications services of the future.

In this context the absence of a policy is even more worrying. The rather feeble attempts of the Peacock Committee to go beyond their narrow terms of reference to consider wider questions of electronic publishing were rebuffed by the government. Yet another opportunity for strategic thinking lost. Those who look at broadcasting from the point of view of telecommunications or IT industries argue for an integrated European approach: massive public investment into a Europe-wide cable system capable of carrying broadcast signals and data, and capable of incorporating the "smart" systems and VANS

(Value Added Network Systems) at the forefront of telecommunications. With such a system programming could gradually expand to meet the capacities of the system. Regulation could be used to guarantee diversity and a wide range of ownership amongst programme providers. Channels for ethnic or cultural minorities (whether football, soul music or ballet enthusiasts) could co-exist without falling under the sway of NewsCorp or Berlusconi-vision.

Such an integrated cable system might well be an inappropriate solution, particularly as off-air transmission techniques improve. The point is that without some conscious planning that situates broadcasting within wider changes, change will inevitably be controlled and regulated by unaccountable private interests. That they often act irrationally and make mistakes only strengthens the argument. Do we really wish to be left with the electronic rubble of failed corporate strategies?

The future of Public Service Broadcasting

For many people the words "public service" conjure up an image of idealistic public schoolboys running the Raj. It is always a service *for* the public rather than *of* the public. As a rallying cry it is tainted by half a century of experience of the realities of state institutions, staffed by professionals confident that they know best what the public needs.

The public service has worked hard to create its own idea of the public, usually in the image of the middle-brow, middle-class nuclear family. In recent debates, one of its defining principles has been seen as what is called universality: the principle that all services should be available at equal cost throughout the UK, from Dover to the Shetlands. But the converse of this idea has been that broadcasting must be geared to a universal, standardised audience, which must neither be alienated nor disturbed by material suitable only for a small part of the population.

The images portrayed by broadcasting have in effect been universal only by creating exclusion zones: generally gays and blacks still make their entrances only in the news and documentaries as problems, or as staples for cheap humour in the comedies. In both cases US imports have a rather better record. It is hardly surprising that recent research confirmed that British black people prefer US programmes. Meanwhile people with disabilities find themselves marginalised into their own magazine programmes and the "TOT" (Triumph Over Tragedy) slots; trade unions appear as the source of unrest and conflict; and the Third World appears as a long run litany

of problems seen through Western eyes (films and programmes actually made in the Third World are caught by the convention limiting imports to fourteen per cent). In each of these cases Channel 4 has made some progress. But as the channel devoted to minorities it has been given the impossible task of compensating for all the ills of British Broadcasting.

Those outside the restricted universality of public service have thus been skilfully wrapped up in a bundle of negative meanings. The demands for positive images and treatment as part of everyday broadcasting have not been met. One broadcaster (who happens to be disabled) described her pleasure at what would be a rare event on British television: a woman in a wheelchair moving around the newsroom in the *Lou Grant* series. She had no part in the episode and her disability was in no way a prop for the narrative. She was just part of everyday life.

Dissatisfaction with the portrayals of public service and its claim to universality has brought many into conflict with the status quo. In this the oppositional left has often found common ground with the libertarian right. On both sides there is deep distrust of both the BBC and ITV's claims to balance and neutrality; their support for a greater use of independents (though on different terms) and a wider range of programme sources; support for a further division between editorial/broadcasting roles and programme production; and for a plurality of openly subjective voices in place of the synthetic objectivity to which the BBC and ITV officially adhere. The big difference between left and right (terms of only limited use in the present situation) are not so much about whether decentralisation and devolution of the monopoly take place, but rather about how regulation adapts to a new environment. The arguments advanced by Peter Jay and others for a wholesale deregulation (the electronic publishing model whereby broadcasting is freed from state restraints) are attractive to anyone who has experienced the exclusive power of the duopoly. There is a widespread feeling that the national state no longer has either the moral or political authority to retain its power over broadcasting.

The deregulators, in both left and right variants, fall down, however, when they reach economics. The tendencies towards monopoly in the cultural industries are most marked in broadcasting. Every experience of deregulation, most notably in Italy where the Supreme Court proclaimed freedom of the airwaves in the early 1970s, has been an experience of the rapid creation of national monopolies. In effect, public regulation is simply replaced by private regulation. Capitalists too, despite their rhetoric, tend to prefer state regulation in practice. Given a choice between the almost guaranteed profits of a (regulated) ITV company and the uncertainties and

potential losses of (unregulated) cable it is not hard to see why.

In many ways the regulation versus deregulation debate has been misconceived. It stems from a failure to understand the nature and complexity of markets. All markets are, and always have been, to some degree regulated, whether by the patronage of a sovereign or the power exercised by market leaders and cartels. Very few markets, by the same token, are ever totally successful in excluding new entrants or preventing change. In certain situations, market liberalisation can be culturally liberating: it can allow new audiences to assert themselves and provide for greater risk, experiment and change. In other situations market liberalisation removes protection from areas of experiment, or producers who serve "unviable" (or simply poor) audiences, and opens spaces for strategies of monopolistic control. The problem is unusually complex in broadcasting where entry costs (particularly to control the means of distribution) are so high.

Originally broadcasting regulation was rationalised in terms of distributing scarce frequencies, and regulatory bodies have been primarily responsible for policing the airwaves and maintaining certain kinds of programme, such as documentaries and drama. Although the IBA is also responsible for awarding franchises it has proved incapable of dealing with the corporate shifts of the 1980s, as franchises are bought and sold as part of broader processes of merger and acquisition. The unfortunate early experiences of LWT and TV-AM, and indeed the whole Independent Local Radio network, showed up the commercial ineptitude of the IBA. In the age of broadband cable the idea of regulation as a form of social contract in which the privilege of occupying public space brings with it certain obligations and duties needs to be extended so that the internal economies of sectors can be regulated as effectively as content has been in the past.

For this to be possible regulatory bodies need a new base for their legitimacy and independence, and at one remove from the patronage of the state. Many different structures (for their membership) have been proposed, including direct elections through the *Radio Times* or alongside national and regional elections, and nominations or representatives from political parties, interest groups and workers in broadcasting. The idea of a number of competing regulatory bodies covering, for example, the areas of licence-financed broadcasting, local broadcasting (radio and cable), satellite broadcasting and national commercial broadcasting has also been suggested. To be feasible, however, such bodies would have to regulate much more than content. They would also be responsible for overseeing the broad economy of each sector, including shifts and concentrations in ownership.

An alternative approach is that a range of regulatory bodies could be based on different "user" constituencies. Given the potential for more channels, the time is ripe for experiment with different models – for example, the consumer based systems in Holland, where funds and studio access are distributed in proportion to the scale of their membership and operations. This gives a wide range of different organisations (including VARA, which has close links to the Dutch Labour Party) an opportunity to present their views unmediated by requirements of balance. In parallel, large cable systems are often owned by housing associations and local authorities, which can ensure that community channels and access are provided.

Under such a system, regulatory bodies would be responsible for different parts of the system. A Public Broadcasting Service (PBS) style channel might be run by a board representing educational interests, minority channels by boards specifically geared to avoid the homogeneity likely in directly elected or patronage-based systems. A range of such regulatory bodies would inevitably have some relationship to government. They would be created by government and would depend on government for the funding framework they would operate – the extent to which revenues from different parts of the system are pooled, levies made on profit or advertising expenditure and so on. There is a strong argument to be made, too, for funding much of a (smaller) BBC through direct funding rather than a licence fee, which is both regressive (i.e. taxes both rich and poor alike) and incapable of keeping up with demand. But despite this economic and statutory dependence on government, regulatory bodies with some form of democratic base and accountability would not be subject to the kinds of pressures seen during the *Real Lives* episode, or the IBA's attempts to suppress revelations about MI5.

The shift to an electronic publishing, free market model, on the other hand, which would remove such dependence at a stroke, is not, in our view, the best way to create a responsive or diverse broadcasting system. The conflict is not a simple one between freedom and state control. It is a question rather of how public safeguards and accountability can be used to guarantee freedoms, both to broadcast different voices and for viewers to experience real choice. The example of the press, usually cited by the proponents of deregulation, seem to us to argue for more regulations, not less. We, like many others, lament the absence, for example, of rights of reply, of finance for minority publications and of the kind of overall political balance that regulation could sustain.

If, as we believe, the public sector has the potential to be genuinely both *for* and *of* the different publics that make up British society – encompassing elected regulatory bodies, minority channels,

a thriving workshop sector as well as mainstream entertainment – the question becomes one of how it can be *widened* rather than narrowed.

As we have suggested, questions of finance are often inseparable from cultural issues. A pluralistic broadcasting system will require plural sources of finance. Over the last few years British broadcasting has managed to expand at roughly ten to twelve per cent per annum at a time when the overall economy has grown at around a quarter of that rate. This has proved possible both because of the gearing inherent in the licence fee (as more people bought television sets, and subsequently more colour sets) and because of the consistently high growth in television advertising expenditure. Clearly this period is now coming to an end. As a result, British broadcasting management has been pursuing a range of strategies to cut costs and increase revenues. Casualisation of BBC staff, increased use of repeats, and moves away from more labour intensive forms of programming, are obvious examples. In revenue terms, greater entrepreneurial zeal in selling programmes, videos and other material has combined with investigations into other forms of finance, such as "subscription", whereby the viewer rents a scrambling device in order to receive channels. According to research by the IBA, the average British household would be prepared to pay up to £500 for a year's broadcasting. It seems probable that the BBC, on the basis of evidence such as this, would be happy to move towards a subscription model to guarantee its independence from government.

British broadcasting thus faces a paradoxical situation. On the one hand, as new media outlets appear – breakfast television, satellite and cable – it is not clear where new funding will come from. Certainly there is little scope in the short term for increasing either the licence fee or advertising revenue. Yet the markets for videocassette recorders and pirate radio have clearly demonstrated new demand. In terms of basic economics, therefore, a socialist broadcasting policy needs to show how the range of broadcast services can be expanded without introducing market principles and jeopardising what is good about the universality principle: that everyone, rich or poor, North or South, can have equal access to the same images.

Part of the solution probably lies in a move to certain forms of direct funding – either through general taxation, the rates or through some form of precept, along with constitutional guarantees to minimise the potential for political arm-twisting. There might also, by following the Dutch model, be some scope for subscription-based services available to everybody. But at least as important as the overall funding of the system will be access to the means of securing finance to enter the broadcasting market.

Existing broadcasting has few owners who do not also have interests in other parts of the media. News International owns shares in LWT. The Mirror Group has interests in Central Television, Radio Tay and Radio Clyde. United Newspapers is linked to Tyne Tees Television, Yorkshire Television, HTV, TV-AM, Capital Radio and Radios Clyde and Hallam. Pearson has holdings in Yorkshire and LWT, Metro and Essex Radios. Fourteen of the sixteen television companies are controlled by sixteen or less shareholders. Forty of the forty-one ILR stations are controlled by ten or fewer shareholders. As in the press, which is now largely owned by overseas interests, similarly rapid inroads are being made into broadcasting. LBC, for example, is 58.2 per cent owned by the Canadian Selkirk Communications company.

Broadcasting is also extremely expensive to operate. An average hour's programming costs over £50,000. Setting up a cable system for 100,000 homes can cost well over £30 million. Sky Channel has already cost around £15 million each year in losses. So straightforward deregulation is bound to confer enormous advantages on those companies which can afford to loss lead in this manner. Indeed the new distribution technologies, with their very high fixed costs, promise an even narrower base of control than existing broadcasting. Similarly, widespread access to production resources cannot be guaranteed in a free market. One solution to this lies in providing alternative sources of finance, along the lines of a Media Enterprise Board. Such a body would have both a commercial and social remit, investing in viable consortia reflecting groups which would otherwise be ignored by business interests, applying for franchises in ITV, local radio, cable or satellite and setting up production companies to serve them. As with local enterprise boards in London, the West Midlands and Lancashire, such a body could also be charged with supporting alternative forms of social ownership and encouraging equal opportunities in broadcasting.

The likely trend in television is not, as some imply, a smooth transition from broadcasting to narrowcasting (services for relatively small, specialised audiences), but rather the development of specialised services alongside mass audience services which will continue to retain the bulk of revenues and the largest audiences.

This will need to be reflected in the nature of regulatory bodies: on the one hand the fairly strict controls (e.g. on balance in news reporting) for mass audience channels, and on the other loose safeguards to ensure balance and diversity across a range of different specialised channels (which could be defined as those channels with less than five per cent of the audience).

Measures such as these are not in themselves socialist. In part this

reflects the lack of any real socialist models which go beyond either replacing the faces at the top (and putting "our" news and "our" morality) or experimenting with small-scale co-operative initiatives at the margins. Nevertheless, alongside a regulated expansion of broadcasting they would begin to promote a broader range of opinion and style. They would provide space for socialist forms of ownership to be developed, and for the labour movement and other movements to develop their own voices. Linked to training programmes to redress the imbalances in broadcasting (perhaps based, like the Job Fit scheme, on a percentage levy on production expenditure) they would result in many more women and black people occupying positions of power.

Somehow, however, there seems to be something missing. Because British broadcasting has been organised around patronage and licence, a move towards greater flexibility and a more genuinely free, if regulated, market, with more weight given to the audience and its diversity, must represent a step forward. But to move beyond this to the articulation of a socialist ethic in broadcasting, beyond the reflection of a mass of aggregated individual desires, is perhaps the real challenge of redefining public service.

At the moment radical broadcasting is thriving on the edge of the mainstream. In the "workshop" movement and the film and video groups of the Independent Film and Video Association, radical practices are being developed involving local communities, and breaking down the divisions between professionals and audience. Working with schools and local groups they are beginning to widen access to the audiovisual literacies so jealously guarded by television professionals. There are now well over one hundred video workshops in all the main cities in Britain. In some areas there is open access to production and exhibition equipment. The Hackney Media Resources Unit, for example, based at Shoreditch Library, provides equipment to over 200 local groups which have paid the £5 affiliation fee.

As the VideoActive report on the distribution of independently produced material showed, many of these groups have yet to discover how to reach their audience. Based on strong organisations, however, video can be used very effectively. One example was the six "Miners" tapes, which were sponsored by the ACTT, produced by a number of franchised workshops, promoted by the NUJ (and most importantly through the pages of *The Miner* newspaper) and distributed through Platform Films in London and Trade Films in the North. The tapes were targetted at different audiences and concentrated on different aspects of the strike. And part of their strength lay in the fact that they weren't broadcast, but were viewed collectively, usually backed by a speaker from the NUM. Links are also being

forged with music. One example was the collaboration on the "Low Pay – No Way" tape by the Hip-Hop Alliance. Another was the Duvet Brothers' powerful video for New Order's *Blue Monday*. In these different ways the seeds of a radical video sector, more concerned with communication than avant-garde kudos, are being sown.

Distribution is also becoming much better organised. The Other Cinema, at one time the major source of socialist films, particularly from the Third World, has been joined by more specialised distributors such as the Cinema of Women, Circles, the Workers Film Association based in Manchester, Team Video specialising in trade union tapes, the ICA Video project, which acts as a channel into public libraries, and Albany Video, which serves the community video movement. The power of distributors in the commercial world is often denounced. But for radical film and video makers it is vital that they can be told where gaps are appearing in the market, what changes will make a film more easily enjoyed and understood, and how best to target a particular audience.

Complementary to a greater concern with audiences is the extension of access to the means of dissemination. The problem with the vision of universal access to the airways, however, is its unreality. It is in many ways more interesting for its role as myth than as a feasible goal. Under any system there will remain professionals, and editors who decide what can and cannot be shown on the most popular channels. No one has the right to be a Michael Parkinson or Terry Wogan (though hordes of people on community radio and cable channels have done their best at palid imitations), and nobody deserves to be subjected to their efforts. Nevertheless, there are many ways in which wider access and audience enjoyment can develop together.

Much work has been done by cable groups in Holland and the United States, and groups such as Sheffield Television Group in Britain, on how news structures and conventions can be overturned to concentrate on what people do that is important, rather than what important people do. Britain's first ever breakfast television service, on an estate in Dunston in Tyneside, for instance, achieved very high figures for local news and broadcasts from the local old people's club. Popular music broadcasting is another field where there is scope for a major extension of access, and for escape from the already hardened conventions of the (massively over-resourced) industry. Though professionals often find this hard to understand, the process of programme making can be valuable in itself. One example was a programme on rape produced by a community radio group on the massive Walworth and Aylesbury estate in South London. Although

the tape was never broadcast, the process of being involved in making it had a major impact on women on the estate, who subsequently played it to many meetings, including a committee of the local council – which promptly agreed all the recommendations it made.

Broadcasting has changed enormously since the BBC first went on the air in the 1920s. The old idea of broadcasting as a means of educating, informing and entertaining is now only a half-truth. The dividing line between the broadcast images and the real world is no longer clearly defined: politics and the Royal Family have taken on the form of the soap opera, terrorist acts and political summits are equally geared to the broadcaster's requirements. Images of riot and death at Crossroads in South Africa sit next to this week's episode from the Crossroads motel.

More than ever before the ways in which we eat, work, look, bring up children, entertain or make love, are shaped by media inputs. At the same time the ability of the audience to criticise, filter and choose has increased in tandem, to the surprise of those who foresaw a one-dimensional public passively consuming images and ideologies.

The history of state involvement in British broadcasting is not the rosy history of success so often described by those who assume that British broadcasting is the best in the world. Many of the best and most innovative ideas have come from outside: from the illegal pirates, independents unable to survive the hierarchies of the BBC, from advertising and radical local groups. In the second half of the 1980s it is Channel 4, ostensibly commercial and financed by advertising, that is doing most to innovate with new forms of television and a new understanding of what public service can mean.

In its most essential, the basis of public service broadcasting is this: that broadcasting is a social phenomenon too important to be left to the dictates of the untrammelled, privately controlled market, and that, as its effects reach everybody, it should be accountable to everybody. The BBC was in many ways an appropriate institution for its era, producing standardised programming for a mass audience through a centralised, hierarchical organisation. But the limits of that era were passed some time ago. Now we face a two-fold task: preserving the old commanding heights from the inroads of private capital while simultaneously expanding broadcasting for small audiences, local audiences and communities of interest.

The state and music: who plays the best tunes?

"You take the pit on a Saturday night or a Bank Holiday. You don't suppose they want Sunday school stuff do you . . . they don't pay their sixpences and shillings at a music hall to hear the Salvation Army . . ."

(Marie Lloyd).

"The main concern of those who have public money to spend on music must be with the sort of music that is not usually regarded as popular."

("Leisure for Living", Labour Party 1959).

"Despite the excellent work which is being done by many music educators, frequently with inadequate resources, musical illiteracy appears, unfortunately, to be the normal condition of our young people. Secondly, there needs to be a completely fresh look at the needs of amateur music making with which the Movement has particularly strong affiliations notably in the fields of brass bands, choirs and folk music."

(The TUC Working Party on "The Arts" 1977).

To the free marketeers the music industry represents an ideal of cultural practice, a model of giving people what they want. To other observers it is in music, more than any other field, that commercialism has most successfully destroyed all artistic values and cultural standards. From the music hall through to the Hollywood musical, via big band crooners crying glycerine tears, or alcoholic song-writers pouring out *Weltschmerz* over a tinkling cocktail piano, and right up to modern heavy metal bands dressed in leather and chains, commercialism is seen to have wreaked havoc with all that music most properly stands for: spiritual transcendence, abiding folk values, technical virtuosity, a national inheritance.

The nineteenth and early twentieth century music hall, for example, was at first roundly condemned for seemingly to celebrate idleness, dissolution, rowdiness and sexual licence. But a hundred years after the first music hall songs were written, they have become an intrinsic part of a working-class urban cultural inheritance. In turn the Hollywood musical, and its choreography, came quickly to exert an influence on "classical" dance and music: Bernstein's scores for *On The Waterfront* and *West Side Story* are now part of the concert hall orchestral repertoire. Raucous rock 'n' roll has also generated a wealth of modern popular musics; film scores are a musical form in their own right, whilst jazz, as the prodigious black American jazz trumpeter Wynton Marsalis has argued, "is the classical music of the twentieth century".

All these musical forms have also been developed outside of the academies, and mostly through commercial forms of production and distribution. The commercial imperative can be harmful and shallow and ineluctably inclined to cultural dilution in the name of profit maximisation; but it has shown a dynamism with no equal in the purer, more insulated and state sponsored forms. After all it is the USA, home of unbridled capitalism, that has been the birthplace of nearly all the important new forms of twentieth-century popular culture. The Soviet Union, by contrast, has produced none.

The success of commercial music is often taken as an argument against any role for the state in supporting and encouraging music. But the state is, and always has been, deeply involved, whether through the impact of the BBC on the dance bands and middlebrow music of the interwar years, the role of disc jockeys like John Peel, Miss P or Janice Long in finding new bands today, in the non-commercial college circuit which sustains the middle-rank rock bands, or in the local authority sponsored concerts and festivals of the 1980s. The Department of Health and Social Security is arguably the single most important source of subsidy for British music.

From another viewpoint, British music is living proof of the possibility of the state acting in the vanguard of culture. The sociologist Tom Burns wrote that perhaps the single greatest achievement of the BBC was to "transform this country from what was musically the most barbarous nation in the world into what has some claims to be the musical capital of the world". Yet in the BBC, as elsewhere in British society, music means many different things. The boundaries that mark off "serious" from "light" music or the more subversive strains of rock are intensely policed. It was only after many years, and indeed arguably only after it had ceased to be a truly live popular cultural form, that jazz was accepted by the BBC or the Arts Council. It was considered a major news story when, in early

1985, BBC Radio Three featured the work of Duke Ellington in its "This Week's Composer" slot, and the *Radio Times* was besieged with angry letters from listeners probably unaware that when Stravinsky arrived in America and was asked the first thing he wanted to do, he replied: "I want to go and listen to Duke Ellington". Rock music only found its way on to BBC radio after the massive success of the pirates had rendered the BBC's ostrich-like position untenable.

Public funding has also been restricted almost entirely to (Western) classical music traditions and their offshoots, with, in recent years, some limited openings towards jazz and Eastern classical traditions. Support from the Arts Council, Regional Arts Associations and local authorities has been concentrated almost exclusively on areas that were once, but are no longer, commercially viable – the pre-electronic forms such as ballet, opera and orchestral music. There are no musical equivalents of the British Film Institute or the National Film Finance Corporation which operated between arts funding and commercial finance. In its early days funding also underwent a rapid shift, away from support for musical activity and participation – the goals of ENSA and CEMA – towards support for a handful of metropolitan "centres of excellence". Labour, for its part, tended to support this approach. In power, the Labour Party has consistently supported this tradition, from the days of the 1945-51 government to the last Labour Arts Minister, Lord Donaldson (education: Eton, Cambridge), who had been a director of Covent Garden for fifteen years and of Sadlers Wells for twelve. Despite the ideology of independence surrounding the Arts Council, the only effective Labour government interventions in its policy were in support of grants to opera: in 1930, under MacDonald a special £40,000 grant was made to Covent Garden: in 1948, £68,000 out of the Arts Council's total grant of £428,000 was specifically earmarked for the Royal Opera House. Two Labour Chancellors, Hugh Dalton and Stafford Cripps, effectively argued for its position as a "special case".

When the party itself organised the Festival of Labour in 1962, the musical menu ranged from the Ipswich Co-operative Women's Choir to a jazz concert in the Festival Hall and a concert by the Philharmonic conducted by Giulini. Organised by the youthful Merlyn Rees (then a relatively junior official at party headquarters) the festival – designed to present Labour's modern image for the 1960s – made no concession to youth culture, skiffle, beat or rock and roll.

The paradox of Labour attitudes to popular music is a consistent opposition to the rich musical heritage of the British working class and the labour movement. Their capture by the "opera class" blinded

them to the vibrant traditions of folk, choral music, brass bands and the music hall. In power, Labour shared the profound class bias which has sustained the bulk of British arts policies since the war: a bias against the amateur and an assumption that because popular and electronic cultural forms are "entertainment" rather than "art" they can be safely left to the degrading impact of market forces. "Serious" culture, on the other hand, demands intensive support and protection. Indeed, in the mysterious ideology that is the worldview of the British cultural elite, the whole cultural scene is in some way dependent on the vitality of a few key symphony orchestras and the Royal Opera House. The Peacock Committee's recommendation to privatise Radios One and Two echoes this tradition. Being concerned with ephemeral, light and fundamentally worthless entertainment there is no danger of commercial pressures having a damaging impact. Radios Three and Four, on the other hand, are seen as serious, concerned with "art" rather than entertainment, and thus are seen to require the protective mantle of public service.

The state of the art

The state of music in Britain today is in fact the situation of many different musics. The scale of music making is itself quite phenomenal. According to official figures there are 567 music societies with a performing membership of 48,000 (and an audience at their concerts of 650,000 each year), 524 folk clubs, 503 folk and country dance clubs, 322 men's and 159 women's morris dancing groups, 115 symphony and chamber orchestras, 85 dance orchestras and jazz bands, 536 ensembles, 79 choruses, 111 early music groups, 1,700 brass bands and 129 military bands. And you can add to that up to 50,000 rock, reggae, soul and other rock bands, untold thousands of discos, sound systems and the music of schools and colleges, as well as an industry that employs 60-70,000 people in pressing plants, distributors, retailing, studios, musical instrument manufacture and marketing.

Although the chairman of the Arts Council describes its role as to support the "living arts", the breadth of music it supports is less than healthy. The marginalisation of non-popular traditions is dramatically revealed in the fact that out of 420 works performed at the Royal Festival Hall during its 1983/4 season only 16 were by living composers. The contemporary classical repertoire is almost literally a nightly Festival of the Dead. The audience for modern "serious" music is negligible. Total attendance at the 93 concerts organised by the Contemporary Music Network in 1984/5 was

15,717, an average of 169 per concert. At the same time the great success of British music has been in rock and pop. With 490 million dollars in overseas royalty earnings in 1985, and roughly a third of the world's hits, the British industry has never been stronger. Its transition from seedy commercialism to respectable industry was marked by the appearance of the Tory Party Chairman Norman Tebbit at the BPI Rock and Pop Awards in 1986.

Attitudes within the Labour movement to the musics have been more than a little confused. The 1977 TUC Policy for the Arts (written by the general secretary of the Musicians Union, John Morton, in the year the Sex Pistols burst onto the scene) talked of "musical illiteracy" being the "normal condition of our young people". Yet it is difficult to square that statement with the dramatic increase in the sale of musical instruments, starting from the early 1960s (and which coincided of course with the advent of British rock and roll), and the common acknowledgement amongst older musicians of the prodigious technical skills of so many younger (and often self-taught) rock and jazz musicians.

The traditional socialist opposition to commercialism also breaks down in the face of the alternative enterprise nature of so much of the music industry. Musical undercurrents have always found their expression in the small recording label or back street club rather than through state sponsorship. From the days of the early blues labels (or "race records" as they were known), through the private jazz labels, the "hot record societies" and famous independents like Blue Note or ECM to the British "indie" outburst of the late 1970s, the record business has given means of communication to groups – urban and rural black Americans, working-class youth, rastas and skinheads – otherwise denied access by the media and more traditional cultural forms.

The relationship between the commercial form of the industry and the often subversive sounds and words of the material it sells is never easy to explain. Punk, which brought with it many hundreds of new record labels, mixed a philosophy of opposition to the exploitative, bland posturing of the industry – the claims that anybody could make music – and a delight in the very structures of managed outrage and hype which sustained that industry. What is consistent is the demand for cultural independence, for freedom either from the narrow commercial demands of major record companies seeking to service an international market, or from dependence on a grant-giving state.

A strong and lively independent scene is in fact a prerequisite for cultural health. Independents act as the Research and Development departments of the major record companies, and in a sense of society

as a whole. Setting up a small label pressing a couple of thousand records or duplicating a few hundred tapes is relatively cheap. It is what keeps the musical market much freer than, for example, broadcasting or film, whose entry costs are relatively massive. Around forty per cent of the new records released each week now come from independent labels, although they hold less than ten per cent of the total market. The biggest problem in sustaining independents is distribution. Tony Wilson of Factory Records argued that "selling is a form of distribution and one of the realities of the record business is that distribution is ninety five per cent of the game". Without physical distribution to retail outlets and the promotion and marketing and radio play to generate demand, independently produced records of whatever quality are consigned to gather dust. A recent decision by the "Our Price" chain of record shops (now owned by W. H. Smith's) only to stock the Top Forty singles, suggests that record buying choice is evaporating at a much faster rate than people thought possible.

The independents, like the whole record business, are also ultimately dependent on radio and, in the age of the pop video, television. Yet the relationship between broadcasting and the more subversive areas of pop music has never been easy. Just as the lawyer at the trial of *Lady Chatterley's Lover* argued that although he could read it and remain uncorrupted, he wouldn't want his wife or servant to read it, so there has been a pervasive idea that the pop public needs protection from challenging ideas.

In 1935 the BBC formally banned "hot music" and scat singing. A series of historic transatlantic broadcasts from live jazz clubs in New York generated horror more than anything at the cockney accent of presenter Charles Chilton, who was summarily replaced by the perfect tones of the duty announcers such as Alvar Liddell (who must have sounded rather strange enunciating titles like "Flat Foot Floogie with the Floy Floy"!). And the tradition of censorship and prudery continues to make itself felt on everything from Max Romeo's "Wet Dream", Jane Birkin's "Je T'Aime", The Beatles' "Day in the Life" to Frankie Goes to Hollywood's "Relax", the Sex Pistols' "God Save the Queen", Paul McCartney's "Give Ireland to the Irish" and Crass' "Sheep Farming in the Falklands".

Radio One has always been deeply ambivalent in this respect. Although it takes all its leads from the industry and the charts, it has never developed an ideology of educating and improving the audiences that could parallel that of Radio Three. Instead, despite exceptions such as Newsbeat, historical series on pop music and the evening disc jockeys, most of its programming feeds directly off the industry's charts. Indeed Radio One recently anounced that it was to return to

use of a fixed playlist. With major chains restricting themselves to top forty singles, those on the outside of the industry face a Catch 22, and a circular formula: without sales there is little prospect of radio play, but without radio play it is virtually impossible to break into the charts.

Far more pernicious than the overt bans (which have in any case often rebounded) has been the covert censorship caused by programming policies, that leads musicians to gear their music to the ears of radio producers rather than a potential audience. Apparently technical arguments about production quality have been used to exclude records which haven't benefited from the lush sounds of expensive recording studios. Bans on videos such as the Police's *Invisible Sun* (which dealt with the war in Northern Ireland) inevitably lead other video makers to avoid jeopardising £30-100,000 of production money on a similarly risky subject matter. Meanwhile overtly sexist material, or videos such as Thin Lizzy's notorious wallow in male violence, *Killer on the Loose*, which was broadcast while the Yorkshire Ripper was still active, are broadcast on prime-time television.

Commercial music video television – MTV in the USA, Music Box in Europe, and a new consortium forming for night-time broadcast in the UK – is no more adventurous. MTV has been notorious for virtually ignoring black American music. As a form of flow programming which viewers drop in and out of a premium is put on consistent production values, rather than anything too challenging or cheap. As a result most videos from the independent sector and anything political or experimental are excluded.

The dependence of Radio One on commercial music, and the taboo on dealing with the political undercurrents of music (how does one "balance" a Bob Marley or Paul Weller song?) also explains the inability of broadcasters to deal with movements like Rock against Racism or the involvement of artists in CND.

New music policies

The selective musical tradition chosen for support by the British cultural establishment has already been well documented elsewhere, although gradually over the years new areas have been incorporated into the Great Tradition. Asian classical music and jazz are two of the obvious examples. Jazz was finally admitted to the Arts Council canon in 1967, when Graham Collier received a small award. Folk music has never been accepted and – irony of ironies – the English Folk Dance and Song Society receives its public funds from the

Sports Council! Deep class prejudice in each case combined with a prejudice against any amateur activity, which was seen as having no inherent artistic value of its own. Funding in recent years for two musicals – *My Fair Lady* and *Oklahoma* – was only rationalised on the grounds that Rogers and Hammerstein might serve as stepping stones to Verdi and Wagner.

Many of the most radical music policies have in practice been followed by local authorities rather than the Arts Council. Local authorities have mixed two sets of goals: providing live entertainment (the Leadmill in Sheffield, Riverside in Newcastle, the Bass Clef in Hackney, the GLC festivals, Camden's Jazz Festival) and providing opportunities for local musicians to rehearse and record. The beginnings of an industrial approach to music, focusing on the importance of employment and economic viability, have also come from local authorities rather than the national institutions.

Taking music policies beyond the narrow boundaries set since the last war depends above all on a level of economic awareness and a breadth of vision that no existing arts institution has been capable of achieving. Investment in small recording labels, or in the manufacture and distribution that sustains most employment in the music industry, requires totally new means of intervention, the use of loans and equity, and training in business skills rather than arts administration. When arts funding began, its narrow remit could be justified by the small sums of money available. A few thousand pounds could do nothing to influence the commercial music industry. But commercial music, for all its success, is just as much in need of state support as opera or ballet. For without state intervention music will inevitably be dominated by the major corporations – in the case of music primarily by the five multinationals which overshadow the world industry, and together control nearly seventy per cent of all record sales. Without intervention, the opportunities for black musicians, regional musics and minority musics will be dependent on the ebbs and flows of the business, and how far the A & R men *[sic]* see commercial opportunities. Without access to the means of distribution and the technologies of recording, the social groups which depend on the music industry start with massive disadvantages.

With the introduction of tape levies and the licensing of all-night music television, the state is in fact becoming ever more deeply implicated in popular music. The problem is not so much that the state is uninvolved, but rather that the need for policy is scarcely recognised. What is needed now is both a cultural awareness of how the sector functions and the economic means to influence how the market works: to make the cultural market free enough for everyone to express themselves, whether or not what they produce conforms to an idea of art or to the demands of MTV and American radio.

The new "local economics", with its stress on socially useful production and the involvement of workers and users in developing products and making decisions, has, by supporting cooperatives and municipal enterprises, chimed in well with the economy of the counterculture. Across the country local authorities are beginning to experiment with different means of intervention which sustain the independence of those making the music. Rather than being organised as extensions of municipal Leisure departments, projects like the Riverside in Newcastle or Firehouse in London are totally independent. The former, a 450-person venue with rehearsal rooms, a hairdresser's and a wholefood restaurant, which was set up with a grant in 1985, is owned through a limited company by guarantee from the 5,200 members who use the club. Firehouse, which links a 24-track recording studio, rehearsal rooms and tour organisation, is run through an innovative co-operative structure which gives equal weight to workers employed by the co-op and musicians who use its facilities as members.

The GLC also showed how music could be used both to embody different policies (such as the commitment to shifting power in London's ethnic minorities) and to influence the industry. Black music in particular received substantial support through subsidised concerts at venues such as the Hammersmith Palais, the Academy in Brixton and the Venue in Victoria, and by participation in the major festivals held in the London parks. The Black Music Roadshow, organised by promoter Wilf Walker, linked a concert programme to a series of short apprenticeship schemes giving young black people experience in promotion, organising tours, mixing and studio engineering. Interestingly, Britain's first compact disc plant, built by a small company called Nimbus in Wales, was financed not by EMI but by the Welsh Development Agency and the Midland Bank.

At a national level, too, central government is beginning to become interested in popular music. The Department of Environment has, for example, been taking a close look at ways of supporting inner city black music organisations like the Brent Black Music Project, which was set up with the support of the GLC. In this the Department of Environment is echoing the policy of the Dutch Ministry of Culture, Recreation and Social Work, which gives an annual grant to the Netherlands Popmusic Foundation (the Stichting Popmuziek Nederland, SPN) as part of its broader welfare policy. Rather than being geared to helping people to express themselves, however, the predominant aim of the DOE scheme seems to be to keep young people off the street.

The Dutch SPN is committed to creating opportunities for "non-commercial" pop music, and acts as the central organisation for the pop collective – groups of musicians who buy equipment together,

perform together and sometimes have someone to deal with financial business. SPN is also working to establish a distribution network for records and tapes recorded and released by groups independently. Alongside the 6,000 pirate radio stations, the SPN does much to bolster Dutch music culture against the Anglo-American programming of the main broadcasting organisations.

A similar approach to non-commercial popular music distribution has been pioneered by Contagious tapes, based in South London. Contagious offers groups access to cheap 4-track recording studios, and distributes C-60 tapes at £2 each. In effect it acts as an umbrella, leaving the musicians to promote and sell the tapes themselves. A similar system could be envisaged whereby a publicly owned tape duplication plant would offer open facilities to duplicate up to one hundred tapes for any band that came through the door. Thereafter access to duplicating facilities would become available once previous debts had been paid off. The total cost of equipment at Contagious is £2,600, including portastudio, synthesisers, drum and bass machines, mastering equipment and special effects. As an alternative to the state of the art digital studios, which cost anything up to £1 million, the project is showing how high technology can be both accessible and cheap.

Socialism and music

Throughout the twentieth century musicians have been attracted to English socialism. Benjamin Britten, Alan Bush, Delius and Vaughan Williams (who argued passionately for the status of folk music as a fine art worthy of public support) and Gustav Holst were all either pacifists or socialist sympathisers. Michael Tippett was a Trotskyist, Cornelius Cardew a Maoist. Folk music has always had political affiliations and close links with the labour movements both in Britain and in the United States where the Wobblies (International Workers of the World) had a particularly lively musical culture. The folk revival which followed the war was strongly supported by the Communist Party in Britain. Jazz too, in Eric Hobsbawm's words, has been noted for its "passionate hostility to the colour bar (and), a marked tendency to sympathise with left wing politics".

Music can be a particularly potent form of political assertion. At the end of 1926 seven striking Nottinghamshire miners were fined £3 each for forming a jazz band and making life difficult for a blackleg. However, popular music has always been stronger on broad expressions of protest than on close relations with political parties inevitably subject to compromise and politicking. Huey Long, the

populist Governor of Louisiana from 1928-35, and the author of his own campaign tune "Every Man a King", has few parallels. The artists who supported George McGovern in 1972 were more concerned to register opposition to the Vietnam war than to back his particular ambitions. The Labour Party has never found it easy to raise the same kind of support. Although Harold Wilson spoke warmly of the beneficial effects of the Beatles on young people, he proudly told the world that his favourite music was *Your Hundred Best Tunes*. In the 1974 election, when the Musicians Union asked for rock artists to support Labour's campaign, there were only two replies: one from Alan Price saying he would help, and one from Ray Davies saying he would vote Conservative. The last tape put out by the Labour Party was not a rousing set of socialist songs but a thirty-one cassette collection of the speeches at the 1984 conference: a snip at £125!

The fact that ten years later the story is different reflects little credit on the Labour Party itself. The formation of Red Wedge in the autumn of 1985 by some of the most successful rock musicians in Britain – ranging from Paul Weller's Style Council to Madness and Heaven 17, Sade and Billy Bragg – is, like the anti-Vietnam movement, as much a reaction to the effects of Thatcherism as a positive endorsement of Labour. Nevertheless, it marks a potential shift in the relationship between artists and a political party. Red Wedge was committed both to winning the youth vote for Labour (many more young people had voted Conservative, forty-two per cent as opposed to thirty-three per cent for Labour, in 1983) and to making Labour a more receptive vehicle for young people's aspirations. The deal was summed up by Billy Bragg: "You change the world and we'll write the songs".

Whether artists can bypass the vested interests of the Labour movement in actually shaping policy – particularly on "hard" issues such as housing, employment, training and benefits – remains more than a little open to question. Where they can, and are, having more impact is on cultural policy. That artists like Billy Bragg (who didn't vote at all in 1983) should be approaching the Labour Party is a reflection of many different forces. The sense of practical responsibility embodied in Live Aid, Band Aid and Artists against Apartheid is very different from the "consciousness will change the world" ethic of the 1960s counterculture or the nihilism of punk.

Despite the lack of any detailed political programme, Red Wedge is also a more clearly thought out intervention in politics than Rock against Racism, in many ways its precursor. RAR, which brought together many of the best black and white musicians, expressed its politics as much through the music (mixed bands like the Specials and

white bands playing within black traditions), as through a political programme. At its height it brought over 80,000 people to Victoria Park in London. Although the subsequent decline of the National Front probably owed much more to Mrs Thatcher than RAR it did show the possibility of uniting skinheads, rastas and young Asians through their pleasures. Red Wedge, by contrast, has at least made contact with one of the levers of power.

Precedent suggests, however, that the Labour Party rapidly loses interest in its cultural identity once it gains power. The independence of cultural movements is bound to challenge the interests of government. After the revolution the Russian Proletkult movement demanded that it should work side by side with the Communist Party rather than in subordination to it. This, perhaps more then anything, convinced the Party that unproblematic high art rather than proletarian popular culture should be at the centre of its cultural programme. Nevertheless, the new currents influencing the Labour Party may make for a different outcome. For those whose political training came in the wake of 1968, the women's movement or black politics, the distinction between politics and culture is not clear cut. Rather than being a tool of politics, works of fiction, poetry, music and film have shaped and defined political identity. The experience of the GLC has also shown how a cultural programme can be used to build support once Labour is in power. Rather than just being an electoral tool to be dusted off before each election, cultural events were used to reach new audiences (through, for example, Asian sports and music, gay festivals, hip-hop competitions like "Young, Gifted and Broke" or events like the Exploring Living Memory exhibition for the elderly) and to build support for particular policies (such as Fares Fair or Peace Year).

When Harold Wilson associated himself with the Beatles and Neil Kinnock appeared in a video with Tracey Ullman, music was being used as little more than embellishment, an extension of public relations. For both the Democratic Party campaigns in the United States and Red Wedge in Britain, a primary purpose of using musicians has been to raise money. The star system in both cases was being exploited rather than challenged. That the music, and the ways in which it is used, could play directly political roles is much more problematic. The (male) sexual politics that are embedded in the sounds, stances and styles of rock also serve to limit its radicalising potential.

The radical cutting edge of music in fact often lies in projects well away from the star system which is at the heart of the industry. It lies in the attempts to create female musical sounds away from rock and roll rhythms, in the collaborations between music and political video

and in the continuing fashion for demystifying the industrial processes of popular music (turned into a high art, and massive money spinner in the packaging of Frankie Goes to Hollywood by Paul Morley and ZTT). The speeches of Malcolm X and Arthur Scargill have been recorded onto a dense electro backing (*No Sell Out* and *Strike* by Keith le Blanc). Test Department who use objects rather than instruments have collaborated with the Welsh Striking Miners Choir. The continuing vitality and commercial success of "ethnic" music, African, Latin American and more recently Middle Eastern is generating fascinating musical fusions around Britain: the WOMAD Festivals and records provide the musical internationalism that was so notably missing at Live Aid.

The intensely worthy experiments of the People's Liberation Music, Henry Cow or, in a different form, Tom Robinson, when concerts ended with earnest discussions, have been replaced by more practical attempts to influence how the industry works and a clearer understanding of the limits to linking fun and politics. Musicians' cooperatives are more concerned with distributing their music or setting up a venue than determining the correct ideological line.

This is where different state policies could be significant. If funding was available for a mixed economy of experimental pop video and cable, for local specialised music radio stations, for independent labels and concerts – in short, for a sector operating between subsidy and the demands of commercial industry – then the scope for experiment and for the radicalising and political (in the widest sense) power of popular music would be vastly greater. Such a programme would also create many thousands of jobs, moving people out of the dole and self-exploitation. This, rather than the massed choirs of the proletkult, would be the embodiment of a socialist culture: independent, in tune with the world and emancipated from the historic poverty of the dime fiddler or pub pianist down on their luck.

In the section on developments in music in its latest annual report, the Arts Council singled out the emergence of "early music" groups as the most interesting and promising new trend of the 1980s. While there may be much to commend the late-medieval world of sackbutts, viols, tambours and crumhorns, it is a striking comment for an organisation committed to supporting the "living arts". To implement a truly radical policy for music will require new institutions: investment bodies, a music industry training board, an academy for jazz as well as the Royal College of Music, and a new approach to broadcasting. And they will need to see technologies as tools not threats, and the world of commerce and the popular as a challenge rather than a problem. These, after all, are the real living arts.

The GLC community arts policy: a case study in local government innovation.

By the time of the final abolition of the Greater London Council, along with the five other Metropolitan authorities, the GLC had become as famous for its arts policy as for anything else it had achieved in its controversial five-year term of office. When people went to the theatre, to the cinema, attended a dance, visited bookshops and crafts studios, watched a video programme or visited a live music studio, they often couldn't fail to notice that the event or venue was "GLC FUNDED". Public subsidy of the arts, often hitherto unnoticed, was given a high profile; and the political dividends paid off. At the end of the five years, the GLC's arts funding policies seemed to reach everywhere, affecting most Londoners' lives in an unprecedented way – like a long and very hot summer. Yet in the original 160-page manifesto for the 1981 GLC elections, drawn up by the London Labour Party, the arts received a mere quarter page of attention. The expansionist and innovative arts programme developed in spite of a rather cautious public manifesto, rather than because of it. Yet at the end of the administration it could be said that the arts programme had become the flagship of the GLC's radical political and economic policy – committed to public growth and a programme of equal opportunities and positive discrimination in favour of London's many minority communities – rather than a minor embellishment on a different kind of political programme.

One of the first actions of the new administration was to shift arts funding from its almost hidden position from within the rather ponderously titled Recreation and Community Services Policy Committee to a space of its own; the Arts and Recreation Committee. This new committee was responsible for all cultural activities, the arts, parks and open spaces, sports and general recreational facilities. A public meeting was then called to discuss a policy statement put forward by the first chairperson of the new committee, Tony Banks. Over 300 people from the major arts centres and community-based

projects were invited to discuss publicly what a radical policy for the arts might be. From that meeting on, the GLC was committed to making all of its committee meetings, and arts policy papers, accessible to the public.

The next development was the establishment of three sub-committees to the main Arts and Recreation Committee: the Community Arts Sub-Committee, the Ethnic Arts Sub-Committee and the Sports Sub-Committee. To all these advisory members were appointed, people with experience and knowledge of the work the sub-committee was set up to fund, and who would, to all intents and purposes, help make the decisions on what projects would be funded. Legally, of course, the final decisions had to be made by the elected politicians, but in the majority of cases they were only too willing to trust the expertise of the people selected to advise them. Advisers were chosen on what appeared to be a rather informal basis, largely as a result of their known work in a particular art form – a selection process which offended some arts activists preoccupied with formal structures of representation and delegation. On the whole though, the system worked remarkably well, its major weakness being that the voices of potential consumers were little heard in the early stages.

The first major policy paper of the Community Arts Sub-Committee, "Commmunity Arts Revisited: A Critical Discussion Document on Policy and Criteria", drafted by Alan Tomkins and presented by Tony Banks, was a major re-working of the notion of community arts, proposing communities of *interest* rather than geographical communities as the focus for support. At the end of the document it outlined four priority social groups whose cultural needs and interests should be addressed:

a) the unemployed
b) youth sub-cultures, particularly girls
c) women's groups and gay men's groups
d) the elderly

This initial check list assumed that needs of ethnic communities would be exclusively met by the Ethnic Arts Sub-Commmittee, although it later transpired that there needed to be a lot of cross funding. It also soon became clear that people with disabilities should be added to the list.

The essential point, however, was that the prioritisation of social groups in need of funding was a radical reversal of traditional arts policies, which start from the financial needs of the art form or institution and only worry later, if at all, about reaching audiences. The first priority of the Community Arts Sub-Committee was to push resources for the arts towards hitherto neglected constituencies. Fortunately Tony Banks was able to persuade his political colleagues

at the GLC on the need for a major increase in the budget for the arts, especially since he was concerned to develop a policy which was not "either/or": either opera or street theatre, either symphony concerts or punk in the park. The GLC policy was always for both. So there was never any diminution of funding to the traditional art forms or institutions. Instead there was a major increase in funding for all forms of arts and recreations.

However, it is one thing to name ideal target groups for funding, another thing to ensure that those target groups are reached and encouraged to apply for funds. Where little provision has existed before, it is very difficult suddenly to stimulate a revolution in demand. It took some working-class cultural organisations in the suburbs three years to discover that the GLC was giving money away to organisations just like their own. In the meantime, the professional arts groups and the existing grant-aided cultural projects in inner London, who already knew the path to and from County Hall, rushed to the new well with buckets.

This inequality of demand was further compounded by the gap between those cultural projects which had full or part-time fund-raisers (adept in filling in forms and knowing which columns on the forms to write "Not Applicable"), and those which were either voluntary or so hard-pressed by the daily exigencies of running their project, that they were unable to do all the behind scenes lobbying to make sure their application got noticed. It was significant that theatre groups were most adept at getting their applications noticed, whereas council estate youth projects, for example, often failed (or didn't know how) to follow through their applications. Clearly any arts policy which is based on targeted groups has to have a great deal of pre-liminary outreach and strategic work before its funding cycle starts, otherwise the already marginalised social groups once again get crushed in the rush.

Apart from targeting particular social groups for funding, it was also thought to be desirable to target particular geographical areas of economic deprivation. London, like all cities, has its social and cultural maps. All the major arts institutions are in the centre of the city, but almost exclusively north of the River Thames. The exception was the South Bank complex, largely owned by the GLC, and the first institution it tried to open out to the people through its highly success-ful "open foyer" policy. The funding strategy was therefore related to areas of the highest economic deprivation, and in this respect was generally successful.

However, even within particular boroughs there were varying degrees of economic deprivation, worlds within worlds, and at that finer level of targeting it was impossible to be exactly sure which

people were getting what, or put more crudely, who was paying and who was getting the benefits?

Main areas of funding

The range of activities funded under the aegis of the Community Arts Sub-Committee was very wide indeed. It included a long string of festivals, both local and London-wide, including the Brixton Festival, the Crouch Hill Festival, and the September in the Pink Festival organised by gays and lesbians. Many other festivals were organised by other GLC departments, most notably the enormous Thames-Days funded by the main Arts and Recreation Committee and the Jobs For A Change Festivals organised by the Industry and Employment Committee.

Arts centres were also funded, including The Albany at Deptford, Chat's Palace at Hackney and the Drill Hall in Camden. Support for venues was felt to be particularly important as a means of creating a physical infrastructure for theatre and other activities put on by community groups. A number of printing and publishing projects were supported, including the Lenthall Road Silkscreen Workshop, The Paddington Print Shop, the See Red Women's Workshop, Only Women's Press, the Peckham Publishing Project, Sour Cream Comics, Sheba Publishers, Gay Men's Press, the Docklands Community Poster Project and Brilliance Books.

Support for community bookshops was another priority, since advisers and members felt this was one of the best ways of supporting writers and publishers. A grant was also given to Turnaround, a national distributor of radical books, in order to help the smaller independent publishers get their books to a wide range of shops. Grants were also awarded to two women's bookshops, Silver Moon and SisterWrite, together with funding for a number of book fairs, such as the First International Women's Bookfair, the Socialist Bookfair, the Irish Bookfair and others.

For the visual arts, support took the form of grants to a range of galleries such as Camerawork, the People's Gallery, the Pentonville Gallery, photography projects like the Hackney Unemployed Media Scheme, Blackfriars Photography Project, the Photo Co-op, the Women's Photo Collective, and to mural and "common service" projects such as the Arts Media Group, the Art Workers Co-operative, Copy Art, WARP, the WEFT Women's Media Resources Project and the Women Artists Slide Library.

Theatre was heavily funded, but priority was given to those theatre groups working with, or organised by, young people, women,

the elderly, members of ethnic minorities and people with disabilities. What was difficult was being able to judge how far theatre groups reached the audiences they wanted to reach (or in some cases claimed to have reached), except for those companies working specifically in areas such as Theatre in Education, a company like Age Exchange, which worked with pensioners' organisations, or the well known and very well liked "Bedside Manners", a company which put on shows in hospitals.

Music was largely funded through support for training and resource projects such as the Brent Black Music Co-op, the Lewisham Academy of Music, the West London Women's Music Workshop, Pyramid Arts and Firehouse Studios, all of which were geared towards not only improving instrumental skills but also committed to training in the use of sound equipment, studio engineering and recording techniques.

It was particularly through its music, film and video funding that the GLC began to come to terms with supporting projects that were also beginning to function in the commercial market-place. This was often to do with the fact that they were electronically based, and therefore directly related to modern large scale cultural production. Albany Video, for example, was responsible for the funding and distribution of *Framed Youth*, a film about young gays and lesbians which was bought by television and has enjoyed a remarkable success in Britain and abroad. A project such as Anarres Video, on the other hand, operated in a mixed economy, doing some commercial work to help subsidise more community-based filming. Women's film and distribution projects such as Cinema of Women and Circles also operated both within the subsidised sector and the commercial film world. A number of London's independent cinemas were funded by the GLC, as part of a policy of infrastructural support for independent film. Had it not been for the GLC some of these cinemas may well have closed, although they are now trading profitably, having been given money for upgrading screening and sound equipment.

Legal and financial constraints

Deciding which projects should be funded turned out to be only the first stage of what became a long-winded and tortuous process. For even after advisers had looked through particular applications, visited the projects, agreed with other advisers and the policy adviser to the Chair of the Sub-Committee, the project then had to be vetted by the GLC's own legal and financial staff. In retrospect it was naïve of the advisers to believe that once the Sub-Committee had voted to agree

funding, all the GLC officers had to do was write the cheque. In between the thought and the deed came the full rigour of local government procedural bureaucracy.

First of all – and this was the most astonishing revelation to the advisers and politicians alike – legal opinion had to be sought in every case to ensure that the proposed grant fell within the statutory rights and obligations of the Council. Suddenly everybody became aware that there was an abstruse theology of local government arts legislation, complete with canonical texts, that had to be invoked every time a grant was proposed. For every penny spent by a local authority has to be spent in accordance with the wording and remit of an appropriate section of an appropriate local government Act. So binding were the constraints upon the arts policies imposed by the existing local government legislation, in fact, that both politicians and advisers had to develop a counter theology of their own within which to cloak the grant proposals.

Since the legislation ran counter to so many of the radical directions which the Community Arts Sub-Committee wished to take it is only right that they be given here in full. For they apply to all local authorities in England and Wales, and will continue to thwart new kinds of arts policies both nationally and locally until they are reformed. The changing of this legislation should be the first priority of any new reforming Minister with responsibility for the arts.

Absolute beginners: a guide to local government legislation for the arts

The GLC funded arts projects under four separate legal powers, one of which, the LCC (General Powers) Act, 1947, Section 59, is of course no longer applicable. The other three powers were different sections of the Local Government Act, 1972, which covers all local authorities in England and Wales. These sections are given below, prefaced by a brief summary of what they were used for.

Section 137: This is the one legal power available under which a local authority can spend money on anything it wishes without constraint. It is a kind of petty cash fund, and cannot exceed the product of a 2p rate. Since many local authorities have in recent years begun to take an active part in local economic development, this is the only power that enables them to do so. The GLC used its Section 137 money to set up the Greater London Enterprise Board as an investment body. The problem is that everybody wants a share of this tiny fund.

Power of local authorities to incur expenditure for certain purposes not otherwise authorised.

137.—(1) A local authority may, subject to the provisions of this section, incur expenditure which in their opinion is in the interests of their area or any part of it or all or some of its inhabitants, but a local authority shall not, by virtue of this subsection, incur any expenditure for a purpose for which they are, either unconditionally or subject to any limitation or to the satisfaction of any condition, authorised or required to make any payment by or by virtue of any other enactment.

(2) It is hereby declared that the power of a local authority to incur expenditure under subsection (1) above includes power to do so by contributing towards the defraying of expenditure by another local authority in or in connection with the exercise of that other authority's functions.

(3) A local authority may, subject as foresaid, incur expenditure on contributions to any of the following funds, that is to say —

 (a) the funds of any charitable body in furtherance of its work in the United Kingdom; or

 (b) the funds of any body which provides any public service in the United Kingdom otherwise than for the purposes of gain; or

 (c) any fund which is raised in connection with a particular event directly affecting persons resident in the United Kingdom on behalf of whom a public appeal for contributions has been made by the Lord Mayor of London or the chairman of a principal committee or the chairman of a principal council is a member.

(4) The expenditure of a local authority under this section in any financial year shall not exceed the product of a rate of 2p in the pound for their area or if some other amount, whether higher or lower, is fixed by an order made by the Secretary of State shall not exceed the product of a rate of that amount in the pound for their area for that year.

(5) A statutory instrument containing an order under subsection (4) above may apply to all local authorities or may make different provision in relation to local authorities of different descriptions.

(6) Any such instrument shall be subject to annulment in pursuance of a resolution of either House of Parliament.

(7) The accounts of a local authority by whom expenditure is incurred under this section shall include a separate account of that expenditure, and section 228(4), (6) and (7) below shall have effect as if any reference to the abstract of the accounts of the local authority included a reference to any such separate account as foresaid.

(8) The product of a rate of 2p or any other amount in the pound for any area shall be computed for the purposes of this section by reference to the product of a rate of 1p in the pound for that area as determined for those purposes in accordance with rules made under Section 113(1)(c) of the General Rate Act 1967. 1967 c. 9.

(9) In this section "local authority" includes the Common Council.

Section 142: This is a legal power which enables local authorities to spend money on information projects and processes. A number of local authorities have used it for advertising campaigns against abolition, against rate-capping and other central government excesses. But the GLC, for example, used it to finance a number of very important films and video programmes on such matters as nuclear defence, public transport issues, women's issues and policing.

It was also very useful in funding arts projects with a high educational or distribution content, such as video production companies, film and video distribution, local history projects and publications, and exhibitions and screenings on a variety of issues affecting Londoners. The present Tory government is anxious drastically to limit the use of this Section, as they strongly dislike what they describe as "political campaigning on the rates".

Provision of information, etc., relating to matters affecting local government.
142.—(1) A local authority may make, or assist in the making of, arrangements whereby the public may on application readily obtain, either at premises specially maintained for the purpose or otherwise, information concerning the services available within the area of the authority provided either by the authority or by other authorities or by government departments or by charities and other voluntary organisations, and other information as to local government matters affecting the area.
(2) A local authority may —
 (a) arrange for the publication within their area of information on matters relating to local government; and
 (b) arrange for the delivery of lectures and addresses and the holding of discussions on such matters; and
 (c) arrange for the display of pictures, cinematograph films or models or the holding of exhibitions relating to such matters; and
 (d) prepare, or join in or contribute to the cost of the preparation of, pictures, films, models or exhibitions to be displayed or held as aforesaid.
(3) In this section "local authority" includes the Common Council and "voluntary organisation" means a body which is not a public body but whose activities are carried on otherwise than for profit.

Section 145: This is the most important Section of the Local Government Act for the arts, and is the one most used to fund cultural projects. It should be noted that it is entertainment based, and is particularly biased towards live performance, arts and crafts, and pre-electronic forms of popular communications. The arcane reference to the "public exhibition of cinematograph films" only confirms the anachronism of the legislation.

Provision of entertainments.
145.—(1) A local authority may do, or arrange for the doing of, or contribute towards the expense of the doing of, anything (whether inside or outside their area) necessary or expedient for any of the following purposes, that is to say —
 (a) the provision of an entertainment of any nature or of facilities for dancing;
 (b) the provision of a theatre, concert hall, dance hall or other premises suitable for the giving of entertainments or the holding of dances;
 (c) the maintenance of a band or orchestra;
 (d) the development and improvement of the knowledge, understanding and practice of the arts and the crafts which serve the arts;
 (e) any purpose incidental to the matters aforesaid, including the provision

of refreshments or programmes and the advertising of any entertainment given or dance or exhibition of arts or crafts held by them.

(2) Without prejudice to the generality of the provisions of subsection (1) above, a local authority —

(a) may for the purpose therein specified enclose or set apart any part of a park or pleasure ground belonging to the authority or under their control;

PART VII

(b) may permit any theatre, concert hall, dance hall or other premises provided by them for the purposes of subsection (1) above and any part of a park or pleasure ground enclosed or set apart as aforesaid to be used by any other person, on such terms as to payment or otherwise as the authority think fit, and may authorise that other person to make charges for admission thereto;

(c) may themselves make charges for admission to any entertainment given or dance or exhibition of arts or crafts held by them and for any refreshment or programmes supplied thereat.

(3) Subsection (2) above shall not authorise any authority to contravene any covenant or condition subject to which a gift or lease of a public park or pleasure ground has been accepted or made without the consent of the donor, grantor, lessor or other person entitled in law to the benefit of the covenant or condition.

(4) Nothing in this section shall affect the provisions of any enactment by virtue of which a licence is required for the public performance of a stage play or the public exhibition of cinematograph films, or for boxing or wrestling entertainments or for public music or dancing, or for the sale of intoxicating liquor.

(5) In this section the expression "local authority" includes the Common Council.

As soon as GLC officers had compiled draft committee reports recommending grants to projects based on advisers' recommendations, they had then to be submitted to the GLC's legal branch. And legal objections came back thick and fast. Here are just some of the kinds of things which the Community Arts Sub-Committee found it couldn't do:

Individual bursaries: Rarely argued for, but from time to time there were cases for awarding individual grants to writers, photographers and other visual artists. Legally this was found to be almost impossible.

Women only projects: A legal minefield, although strenuously argued for throughout the GLC administration – particularly the right of women to organise and run women-only cultural venues and programmes.

Trading organisations: Objections to trading organisations came from both legal and financial officers, principally based on the notion that a trading company could not be involved in providing a local cultural facility! This surfaced in relation to community bookshop projects who used trading surpluses, where they

existed, to cross-subsidise other activities such as literacy classes, advice centres and so on. Art, it seemed, could not co-exist with commerce.

Local history projects: Local oral history projects, particularly linked to pensioners' organisations, were objected to on the grounds that they were nothing to do with "the knowledge, understanding and practice of the arts". Ways were found eventually to overcome these objections.

Technical training in modern communications: Film/video/radio training projects for young people, particularly young women and members of ethnic minorities, were objected to again because "technical training" was considered nothing to do with the practice of the arts.

Distribution projects: Whilst legal clearance was not too difficult for the various forms of cultural production – publishing, film and video making, record production – it was almost impossible to get legal clearance to provide "arts" funding for distribution projects, obviously essential to the wider success of the production projects. The sub-committee wished to fund at least one major independent book distributor as well as a number of video distributors. They were able to do so eventually, but only after the commmittee reports had been worded in the most ambiguous and theologically correct ways. This also applied to other "servicing" projects for the arts, such as marketing and promotion companies.

Benefits to Londoners: Not surprisingly, local goverment legislation requires a service to be funded to be of exclusive benefit to the people served by the local authority in question. This clearly creates problems for projects such as film and book distributors, touring theatre groups based in London, and many other projects whose services are used outside the city funding them. At its crudest level, legal objections to funding projects with a national arena were answered by ascertaining what percentage of the project's work was of direct benefit to London people. So in the case, say, of a gay publishing house, it was estimated that some seventy to eighty per cent of its books were sold in London, and therefore the project was eligible to that same percentage of its anticipated revenue deficit. Film distributors also had to provide evidence of London usage.

The irony of this kind of limitation was that for many projects, such as distribution ones, it was the national and even international sales which provided the projects with financial stability and which therefore secured the London based jobs of the project and their continued ability to provide the service for Londoners. So advisers

and grant officers had to argue the job security case rather than the artistic benefits case with regard to the "benefits for Londoners" clause.

There were many other variants of legal objection, and though most of them were overcome in time by new and different and more subtle kinds of legal wording, the fact is that the legislation effectively slowed down the arts policy and created enormous frustration for the politicians, advisers, grants officers, and of course the projects themselves.

Having secured legal agreement to the wording of a committee report, it was then necessary to secure the agreement of the finance department. This was also at times highly complicated, and conditions were imposed which placed a great strain on the majority of projects. The following list gives some idea of the constraints:

One year at a time: This is a traditional cycle for local government funding, obviously suited to its budgeting, but in many cases disastrous for applicant groups. It often means that more than half a year is spent worrying about the current grant which has not arrived, or the next year's grant which has to be applied for. The insecurity is very demoralising and means that more time is spent worrying about finance than on doing the work the finance is intended to support. This is particularly the case with new projects, which might be better supported by a three year initial funding package.

Capital costs: Money for items of equipment, or the buying of leases, is the easiest to ascertain and check. Yet when it came to payment, groups were often asked to produce invoices before the grant money was released (though later this was amended to the presentation of pro-forma invoices). The assumption was that groups already had some capital to spend.

Revenue costs: This covers recurring expenses such as rent, rates, heat and lighting, salaries. Naturally these had to be based in many cases on estimates and notional budgets. It so happened that by the time the thousands of applications had been sifted through, projects chosen, visited and assessed, most of the financial year had already gone. This resulted in the situation that the longer groups had to wait, the smaller was their revenue grant (which could only cover monies actually spent). And the groups refrained from spending money before knowing if their grant was going to be secure. Towards the end of the administration the most common form of grant was for an anticipated "revenue deficit" – the sum by which expenditure had exceeded income – if the project had actually taken the risk of spending money in advance!

"Bums on seats": The traditional yardstick for measuring the cost-effectiveness of arts funding has been to calculate the subsidy per head of user. Finance officers came into direct conflict with advisers over this criterion on many occasions, the advisers arguing that a community arts policy devoted to a "process" or workshop type approach, rather than performance/exhibition, would require a greater subsidy for a smaller number of people to be effective.

An agreed rate for the job: It quickly became evident that the range of wages being paid in the community arts sector was staggeringly wide: from trades union members in film crews earning good salaries to projects in which the workers mostly subsisted on the dole. It was argued that the sub-committee should pay the appropriate trade union rate for the job. But what if for some this was £12,000 a year and for others £80 a week? This would mean that the sub-committee was endorsing the very large wage differentials already apparent in the sector. It was decided to award a standard "contribution to salaries" of about £8,000 per job, rising to £9,000 a job in 1985.

Successes and failures

When the GLC Community Arts Sub-Committee came into being in 1982, there was already a "dominant ideology" within community arts, even if it was from time to time fiercely contested. That ideology concerned the overriding importance of "process" in the practice of community arts, as against a concern for products, performances or – as some critics cuttingly argued – pleasure. Community arts was about letting everybody have a chance to be involved in cultural production, irrespective of whether there was any product at the end: the journey was more important than the arrival, the means more important than the ends. Community arts was decidedly not about audience or artefacts, but about self-activity.

In practice, much community arts work took the form of street festivals or carnivals, community murals, silk-screen poster workshops, photography projects, large scale drama projects building towards a single performance, music workshops and so on. Commuity arts was mostly located in working-class council housing estates, or in arts centres serving working-class districts, and was rooted in earlier political (but also philanthropic) models of the agitator or missionary encouraging self-activity in places seemingly deprived of resources and beaten down into a culture of silence. The role of community arts was to become the spark that lit larger and

more ambitious political and cultural fires.

The most favoured form for community arts – as it was to be for so many other radical initiatives in the 1970s and 80s – was "the workshop". As Musical Youth sang on their hit record *Pass the dutchie*: "We learnt it at the musical workshop". Drama workshops, writing workshops, photography workshops, video workshops, mural workshops, silkscreen workshops were all part of the community arts movement which dominated radical arts thinking in this period. But a Sub-Committee which only funded this kind of activity would, in fact, have just been funding a network of professional community arts workers, with possibly even fewer resources actually going to the majority of Londoners untouched by these practices. For that is one of the drawbacks of a totally participatory theory, that only a tiny minority of people could ever be involved at any one time.

It was also impossible completely to mesh the principles of community arts practice with the new priorities in the allocation of resources to groups such as women, gays and lesbians, members of ethnic minorities, working-class writers' workshops and community publishing projects, who already knew what they wanted to do, and how to do it, but simply lacked the financial means to put their cultural projects into practice.

At its most extreme, the dominant ideology in community arts rejected any notion of "repeatable performance" in drama, for example. Every production had to be the first and last – it was the process that was the key thing. Yet clearly touring women's theatre groups, and many others, saw their role as being to take radical theatre to a variety of new audiences in new venues, rather than to stay in one place and work with the same group of people on one performance. The compromise was – and in this case turned out to be a positive development – that funded groups were asked to attach workshop type activity to their existing forms of production. That is to say, a touring women's theatre group would be asked to run a workshop at the venue of the performance, either before or after the actual show. The imposition of the workshop process on many projects was widely beneficial, as long as it was understood that not everything in every art form could simply be done on the spot with whoever turned up. There were other definitions of cultural democracy.

It also became clear to many advisers – as it certainly was to officers in the finance department at the GLC – that levels of financial competence within a number of arts projects were very low. Many were too small to employ a specialist book-keeper/fund-raiser – someone able to provide fairly accurate budgets for projects, cash-flow projections, match sources of funding against reasonable levels

of expenditure, develop an asset base against which short and medium term loans could be obtained, and generally be able to know at any one time the financial stability of the project. This is not surprising since the majority of projects had emerged within the subsidised sector, with small numbers of staff, and used to working on a straightforward grant-aided basis.

Clearly nobody at the GLC was arguing that innovative theatre projects, arts projects working with the elderly, youth arts projects – in fact the majority of those funded – should be in any way profit-making. On the other hand, many had the potential to become economically self-sufficient to some degree over a period of years, but simply had not thought in this way. The weakest part in the majority of applications was on the income side of the balance sheet. Most groups could work out how much they wanted to spend in a year – on a series of publications, on a film production, on a touring theatre show, on a music festival – but few had really developed strategies for maximising the amount of revenue they could earn from their activities.

Several publishing projects, for example, applied for funds for quite exciting publishing programmes – but failed to itemise any details in the budget for promotion and marketing costs. They simply had not developed strategies for selling the books they wanted to publish! Some theatre groups consistently failed to get audiences for what were very fine productions, again because of poor advertising and promotion campaigns. It seemed that often arts workers were so completely tied up in the excitement of production that they found questions of audiences, readerships or viewers rather less interesting. Everybody wanted to be in the play, but nobody wanted to sell the tickets!

This indifference to the interests of possible audiences is most clearly exemplified in the Video-Active report on independent video production in Britain, in which some 150-plus productions were listed with embarrassing details as to how few of them were ever hired or sold: less than five times in the majority of cases. The lack of sales or screenings per production is particularly depressing given the amount of money that each production cost, and one of the first initiatives of the Greater London Enterprise Board's Cultural Industries Unit was to look at more effective means of promoting and marketing independent video production. Out of a forum of London-based distributors, a number of projects emerged, one of which, the ICA Good Video Guide, largely as a result of its attractively produced catalogue aimed at public libraries, sold more independent videos in three months than had probably been sold in three years by the groups doing it on their own. The strategy of funding "common services" for whole sectors, such as book distribution, video promotion or

independent record catalogues, made more sense to GLEB than funding individual projects or campaigns.

One of the community bookshops which applied for funds was found on close inspection of the budget – and audited accounts for the previous year – to require a subsidy of £1 for every £1's worth of books it sold. Several projects had applied for funds to buy computers which, having bought them, could not find anyone to use them. One or two projects having received their grants seemed to spend most of their time having internal staff meetings and arguments, or engaged in internecine ideological wars with each other, having closed the doors to the public. Criticism should be made in such cases because in most other respects the policy and the results were a resounding success. The majority of people in the projects worked hard and came up with remarkable achievements.

Rather late in the day, the GLC commissioned Comedia to do some consumer research to see if the community arts policy had actually reached the people it was intended for. Over 900 people were interviewed in three districts in which there were a number of GLC-funded community arts projects. Nearly forty per cent of those interviewed said they had used one of the community arts facilities in the previous year, a very high and impressive rate of take-up, with the largest single category being the unemployed.

The major characteristic of the people who took advantage of the arts policies of the GLC, however, was – and here the policy did share some of the same patterns as traditional arts – educational qualifications. Between fifty and seventy per cent of those interviewed who had attended arts events had qualifications at "O" level or above, a figure very much higher – and therefore unrepresentative of – people at large. It was also found that the concessionary prices offered by GLC-funded projects were used to more advantage by middle-class than by working-class users.

The Comedia report concluded with a strong recommendation that all future arts programmes should be regularly monitored to find out which precise sections of the population were using them and why. This we feel is of paramount importance. Too many arts projects for too long have made extravagant claims about who uses them, claims which have never been tested to any degree of accuracy. The client base of the Royal Opera House is well known, as is that of the major West End institutions. But it may also be true that even in mainly working-class districts, it is the numerically smaller middle class who take advantage of whatever subsidised cultural programmes are available. If the old pattern by which arts spending means the continuing displacement of resources from working-class taxes to middle-class consumption is to be changed, then regular user surveys are an

integral part of a democratising cultural policy.

It was in the film and video sector that some of the most far-sighted GLC funding was achieved. Surveying the dozens of applications from would-be production groups for expensive capital equipment, the film and video advisers, together with some of the finance officers, called meetings of all the applicants and told them to rationalise their applications. This meant that groups in the same geographical area would have to agree to share equipment where necessary, in effect the strategic allocation of scarce and expensive resources. It was precisely this kind of thinking that was later developed into the cultural industries strategy at GLEB, where it was realised that a strategic plan of common services for cultural projects – effective book distribution, a theatre touring agency, a forum of video distributors, and so on – could help the multiplicity of small producers find new audiences (and therefore paying customers) for their work, and put some of them on the road to economic self-sufficiency.

The GLC arts experiment was in many ways a hot summer full of pleasures, rows, controversies and new experiences. It was the first time that the doors of power had been so explicitly thrown open to new constituencies, many unfamiliar with the ways of power. This did not result in a mass outburst of sweetness and light. The relationship between organisations, the GLC bureaucracy and the politicians was often tense and contradictory. The rainbow coalition included many conflicts, and just who could claim to represent its different parts was always problematic. The question of what the GLC was doing for the traditional, white working class, for example, was never satisfactorily answered. Yet, as Stuart Hall wrote:

> "The ding dong, complaint, pressure, pushing and response
> between the movements and the politicians is the positive
> sound of a real, as opposed to a phoney and pacified,
> democracy at work."

It is precisely this sound that has never been heard in the corridors of the BBC or the Arts Council. Theirs has always been a pacified democracy of secret criteria and even more secret decision making: the world of the "quiet word" rather than the fierce argument and counter-argument of newly discovered tongues and voices.

Labour and culture: dancing into socialism?

> "Even the Labour Party, culturally the least ambitious organisation ever produced by the British Left, felt obliged in its early years to maintain a musical side."
>
> (Raphael Samuel, *Theatres of the Left*).

In other times, or in other places, socialists might find this current search for a cultural policy a distinctly quixotic enterprise. Surely, they would argue, since the interests of the people are objectively synonymous with the interests of 'the party", then a socialist cultural policy is expressed automatically through a strong party culture. And we know there have beeen examples of this. For in the formative years of British Socialism between 1870 and 1900, many working-class and middle-class people found, so we are told, their every emotional and recreational need satisfied by membership of the early socialist and working-class organisations – the Social Democratic Federation, Socialist League, Christian Socialist movement, Co-operative Society, Trade Union, Friendly Society, Labour Church, Clarion organisation and so on.

The aim of such "pre-electoral" political organisations was not simply to recruit sufficient numbers of like-minded people to eventually take power and run society on behalf of "the rest". Their ideal was rather to universalise the membership of their own organisations, sharing the daily life of fellowship and self-management and building the new society from below, brick by brick. Little attention was given in this period to the problem of taking over the state.

In some small towns and city districts, relatively strong autonomous cultures were slowly built up by socialist activists and other sympathisers to "the Cause". At work they may well have belonged to strongly-knit craft trades unions with an active branch life; they may have attended weekly meetings of the friendly society which they directly controlled and which insured them and their families against sickness, unemployment or bereavement; they shopped at the Co-operative stores, which again they managed as

shareholders; at weekends they may have gone speaking and re-cruiting locally for the cause, or gone on rambles with other comrades; and they may well have spent part of their Sunday in a Labour Church singing Labour hymns, followed by an evening social with food and entertainment organised by themselves. A recently published and convincing portrait of this kind of self-contained culture can be found in Linda McCullough-Thew's *The Pit Village and The Store*.

The good society, the socialists of this period would have argued, was something like this for everyone. They did not feel themselves to be "culturally disadvantaged" or "unenlightened"; if anything they felt the opposite, that they had come into the light and were living worthwhile lives uncomplicated by adornment or artifice. William Morris' influential *News from Nowhere* imagined a world without art, in which the beautiful was also the practical. Art was craft, aesthetic values were directly related to usefulness, and culture was pre-eminently about the quality of daily life. This was a world which had no need for an Arts Council.

To what extent this picture is an idealisation of the past, reflecting a large degree of wish fulfilment by contemporary historians and their readers in the face of current political fragmentation, is a matter for debate. The authors and editors of this book are in fact divided on this question too. The past is always much less complicated than the present; memory smooths down the awkward edges and turns the jagged rocks into polished stones. Golden ages in the past, we are told, properly belong to conservative ideologies; for Socialists the golden age is in the future.

In many ways, similar aspirations to those of the socialist "pioneers" were expressed in the hippie movement of the 1960s, where "lifestyle politics" emphasised the quality and nature of day-to-day life, and in which the role of alternative institutions – underground bookshop, wholefood shop, communal living accommodation, collectively owned smallholding or workshop, underground press, rock music culture, alternative medicine – was again central. Much as we might sneer today at the gullibility of those who turned away from the main task of grasping state power, it is interesting that so many of those alternative institutions – the bookshops and small presses, the health food shops, the alternative forms of medicine – became focal points for a new socialist politics in the 1970s and subsequently sites for big business exploitation in the 1980s.

It is also salutory to recognise that the aim of building an oppositional culture based on autonomous institutions has been one of the reasons for the continuing strength and political achievement of feminism. For the feminist case was not just argued within existing magazines, newspapers, political groupings, but was developed

through new and separate forms of organisation. In America, such was the size of the gay and lesbian community which emerged from the libertarian sexual politics of the 1960s, that within a decade leading economists had to take seriously the fact of "the pink economy" and endeavour to exploit it at the same time as acknowledging its existence. Cultural choices are political and economic choices too.

Classical Marxism, and the Labour Party variant of that kind of economic determinism, have always put economics first and made all other aspects of life secondary issues. Not surprisingly the Labour Party has therefore always found difficulty in recruiting people to its ranks other than through the largely male, work-based organisations of the broader labour movement. Reaching people through their pastimes and pleasures (one of the great strengths of the Young Conservatives, whose primary function centres on social events) has never been the party's greatest strength.

The socialists of the late nineteenth century, we are told, were able to create a separate culture in which they lived, worked, took their leisure and died. The cause was everything and everything was the cause. Yet the conditions were perhaps never again so propitious. At that pre-electronic time there was no fully developed capitalist leisure industry. There were no cinemas, no recorded music, no wireless, no television, no cars, few organised sports, and the commercial music hall was only just beginning. What commercial forms of culture existed were mainly books and serialised magazines, triple decker novels and penny dreadful magazines.

Of course there were the pubs, alongside which many workers' organisations developed their own working men's clubs and institutes. In those vital decades it was quite possible that the socialists had all the best tunes. Against Victorian religious morbidity and dourness, the socialists could offer another version of moral organisation and system of beliefs, complete with hymnals: *Chants for Labour, A Song Book for Socialists, Machine Room Chants*, the *Labour Church Hymnbook, Labour Songs for the Use of Men and Women* and many others. Open air meetings would begin and end with singing, rambles into the countryside at the weekends would be accompanied by the singing of songs, and in adversity, as when a group of socialists were ejected from Lichfield Cathedral for being too noisy, they responded by gathering outside and singing "England Arise".

Today it would be foolish to suggest that the Labour Party could develop its own autonomous culture, separate and distinct from the forms and achievements of both bourgeois traditions and the modern forms of popular culture. Even so, the degree to which the Labour Party has signally failed to develop any traditions of its own, any

emotional and cementing bonds of membership other than those generated by the minute book, standing orders and the constitution is an admission of a political lack of imagination of major proportions. Today there is hardly a hint of a cultural ghost in the election machine. Although the party is slowly becoming aware of the need for a cultural identity it is inevitably hard synthetically to create such a tradition. The brass bands and Humphrey Lytteltons sit uneasily with the Red Wedge rock stars for whom Labour is simply the least worst party.

Many journalists and Labour Party people who went to Sweden at the beginning of 1986 to attend the funeral of Prime Minister Olaf Palme, came back astonished to realise how strong a party culture the much maligned Swedish Social Democrats continue to sustain, and which helped account for the huge public distress and waves of spontaneous meetings and ceremonies which were organised in response to Palme's assassination. The Swedish Social Democratic Party still has factory and workplace branches. The party lapel badge is worn widely and is a common sight on bus or underground. The party is the single largest organiser of adult education in Sweden, through a wide programme of classes in its own adult education centres and colleges, and through its national correspondence school, Brevskolan. It was also very active in promoting a movement of indigenous Swedish rock and folk music in the 1960s and 70s, in protest against the almost total Anglicisation and Americanisation of popular musical culture. It has its own arts organisation which commissions prints from contemporary Swedish artists. These are then sold at reasonable prices to trade unions, schools and colleges, offices and factories, and can be seen widely. Go into any Swedish Social Democratic Party or trade union office, and contemporary paintings (many with a working-class theme, historical and contemporary) can be seen everywhere. The party was also responsible for a Literature Promotion Project through which commissioned working-class novels were published in very large editions and sold in attractive covers and at cheap prices on every tobacco kiosk in the country. May Day rallies in Sweden still manage to be large, popular working-class demonstrations. The party may, as its critics argue, be over-protective of its membership, and suspicious of too wide a diversity of opinions, but at least it believes that party membership is more than mere card-holding and canvassing every few years at local and national elections.

It would be embarrassing to contrast the attractiveness of the buildings, publicity material, education courses and many other facilities which the Swedish SDP offers its members with the uniformly drab Labour Halls and Labour Party meeting rooms which

one finds so often in Britain: filthy windows with out of date faded posters peeling from the woodwork, little evidence of opening times, large padlocks on the door. And yet these belong to the party which promises a new world of hope and joy. People don't take long to realise the contradictions. One of us active in Labour politics in a large town in South East England remembers the Labour Party hall as being the scruffiest building in the whole town. Inside the walls were bare, the radiators and paintwork a municipal antiseptic green, the rooms lit by naked light bulbs, half the chairs broken, such crockery as there was stained and cracked, and the whole building saturated with a musty, dry rot smell. This was an advertisement for socialism? And yet the ironic thing was how few people who used the building worried about its dilapidated state. For they too were affected by that characteristic indifference to the material environment which is a hallmark of socialist puritanism.

This was surprisingly the case even at the much-lauded GLC during the last administration. Many socialists who went to work there didn't change the country house reproductions on the wall or even rearrange their offices during a three- or four-year stint in the building. When they left in 1986, their rooms were just as drab and unadorned as when they arrived. In many rooms there wasn't the slightest material shred of evidence to suggest that there had been a different kind of political regime there between 1981 and 1986. Some socialists have often cultivated an air of untidiness and squalor as somehow being more authentically proletarian than cleanliness and attractiveness, both in dress and in working and living environments. As long as there is an old cup or saucer to stub the cigarettes out in, a few chairs to sit on, then for some that is all that the stopping stations on the route to socialism need. Or as a cynic once remarked, "How come they say they can change the world, when they can't even change a light bulb in the Labour Club toilet!"

This cultivation of the "Mock Proletarian" style in dress, material environment and social relationships is profoundly masculine, as is so much of Labour Party informal culture, and affects a disdain for the "domestic" or "feminine" virtues of tidiness, concern for comfort, the provision of refreshments (unless perhaps the ladies would care to rustle up some tea?). It evokes a well known joke of the 1945 election when a Tory MP claimed to be able to tell the socialists by the fact that "they didn't wash their milk bottles". But even more worrying is the gap which so often exists between what party activists accept as reasonable conditions in political culture and what they accept as reasonable in their private lives: the gap between the dirty meeting roooms and the stripped pine kitchen and expensive hi-fi back home. In 1961 Hugh Gaitskell, then leader of the Labour Party,

called for a campaign for brighter buildings – for party premises – but with very little effect at all. Private affluence and public squalor still seems to be the socialist reality.

Is it surprising then, that when Labour pronounces on the place of art in people's lives, in the joy and hope that will arrive – like Walter Crane's famous May Day engraving of Liberty, garlanded in flowers – that people are slightly cynical? For if a party has no internal cultural policy of its own, nor history of one, then how can it possibly develop a cultural policy for a whole nation? Who would trust a restaurant in which the people running it chose to eat in a café on the other side of the road?

Not that one should just blame the Labour Party for such an appalling history of indifference to the role that cultural movements play in social change (a leading role in our opinion). For no matter how many histories of the left parties and sects one studies, or how many biographies of leading figures, it is salutary to note how rarely is any reference made to cultural questions, or detailed descriptions of the role the political movement made in people's lives. Yet in talking to elderly political activists, and through reading much of the invaluable oral history work stimulated by the History Workshop and community publishing movements over the past two decades, it is clear that what people remember is not the conference resolutions which were passed, the details of the party programme or the organisational structures (the very stuff of orthodox Labour Movement history), but the quality of comradeship or support and help that came with a branch life, and the sense that their involvement in a political organisation – whether trade union, political party or Co-operative Women's Guild – gave a feeling of hope and meaning to their lives.

A provocative study of the early socialist movement, Stephen Yeo's *The Religion of Socialism*, is full of moving testimony to the comradeship of branch life. George Lansbury, remembering the varied activities of the Bow and Bromley SDF in East London, recalled meetings that opened and closed with songs, and with reference to the regular Saturday evening dances the branch organised, "humorously telling our critic we were going to dance into socialism . . ." In this period, for example, South Salsford SDF had its own orchestra, Bolton ILP a cricket club, and many ILP branches had glee clubs for Saturday night socials, or "come-as-you-please" evenings. And naturally the working men's clubs had their own bands too, as did many trade union branches, as well as choirs. Possibly the greatest attempt to link politics with people's recreation was that of Robert Blatchford's Clarion movement, which was an independent socialist movement with its own journal, a rambling organisation (The

Clarion Scouts), a network of social clubs (The Clarion Fellowship), a network of cyclists' clubs (Clarion Cyclists), and a number of drama groups around the country (mostly called Clarion Players).

It should be remembered that it was the socialists of the time who championed the work of Ibsen, then considered controversial, with Eleanor Marx teaching herself Norwegian so that she could translate *An Enemy of the People* and *The Lady from the Sea*. For this was an era in which some aspects of socialist cultural politics were in tandem with the experimental and avant garde. The Glasgow Clarion Players, however, formed themselves into the Clarion Comedy Club and advertised for scripts to make their audience laugh. ("We are rather afraid that those plays mentioned in the Clarion lately are too heavy and serious for our purpose"). The Clarion Players in Newcastle, established in 1911, still survive today, albeit with many adaptions, as The People's Theatre.

Jack Jones, who later became General Secretary of the Transport and General Workers Union, remembers the formative influence that his early reading of Tressell's *The Ragged Trousered Philanthropists* had upon him: "Take *The Ragged Trousered Philanthropists* – I must have bought half a dozen copies of that. You lent it and it didn't come back. The circulation of that book was remarkable . . . that book was a great introduction to socialist and trade union ideas!" Jones also remembers the impact that play readings organised by the Liverpool Labour College had upon himself and others, particularly Eugene O'Neill's *The Hairy Ape*. It is likely that Tressell's novel converted more people to the ideas of socialism than any party manifesto or editorial. The same might also be said for the plays of Shaw, which so many older activists remember having a profound impact on their thinking. The Labour Party and many other socialist parties and sects have consistently under-valued the vital – and some would argue pre-eminent – role which literature and theatre have played in changing people's ideas.

This can be clearly seen in the testimony of members of the Co-operative Women's Guild, collected in *Life As We Have Known It* (Virago, 1977), which includes a whole section in which Guilds-women write about the books they have read and which have made an impact on them. Worth savouring too is the testimony of just one of the contributors, Mrs Layton, a working-class woman from Bethnal Green, who wrote that

> "Sometimes my husband rather resented the teachings of the Guild. The fact that I was determined to assert my right to have the house in my name was a charge against the Guild. The Guild, he said, was making women think too much of

themselves. I did not quite agree with him there, though I did and still do think the Guild has been the means of making its members think more of themselves than ever they did before. The Guild's training altered the whole course of my life. When I look back and think what my life might have been without its training and influence,I shudder".

A night out with the Labour Party

Not that the Labour Party branches did nothing. Such preliminary research as exists paints a picture of sporadic activity in the 1920s and 1930s by branch, constituency and city parties. At the Town Hall, Dunstable, in 1925, the Welwyn Garden City Labour Players staged a performance of *The White Lady*, a play about the plight of nineteenth-century farm labourers, written by the group secretary. In Woolwich, the Social Committee of the Labour Party set up the Woolwich Labour Thespians, described in its time as "one of the best amateur dramatic societies in London". In 1926 the members of the Hackney Labour Party, already organisers of regular Saturday evening socials with tea, biscuits and lectures, decided to stage their own plays. A few performances of one act plays written by well known playwrights encouraged some of the members to think about writing their own, as well as adapting that most inspirational novel, *The Ragged Trousered Philanthropists*, for public performance. This early move in fact laid the the foundations of the Workers' Theatre Movement, which went on to develop much closer political and cultural links with the Communist Party.

In 1924 Herbert Morrison, the machine politician *par excellence*, set up the London Labour Choral Union and organised a festival of music for Labour Party organisations, which was judged by Vaughan Williams. (It is worth remembering how nearly all the classical composers of that period – Vaughan Williams, Holst, Delius and later Britten and Tippett – were sympathetic to socialist and pacifist politics.) Morrison went on to establish a London Labour Dramatic Federation and a London Labour Symphony Orchestra too. The Choral Federation consisted of about twenty local party choirs, with a membership between them of 600, the Dramatic Federation had some fifteen member groups. (It has to be admitted, though, that both these sets of figures pale into insignificance beside the activities of the Royal Arsenal Co-operative Society in London, which in 1928 was sustaining some 280 drama and music groups.) Elsewhere, the Socialist Film Council produced in 1928 two of its best known

productions, *Blow, Bugles, Blow*, a pacifist melodrama, and *Labour and Love*, the story of the political conversion of a Tory activist after he falls in love with a Labour woman, the film being produced entirely by a Nottingham ward Labour Party branch, with the ward secretary starring as the converted Tory.

However, it was the British Communist Party which in the 1930s eclipsed the cultural activities of all the other left parties and sects. The Workers' Theatre Movement, which had originated with the Hackney Labour Players, became directly engaged in general Communist Party propaganda and recruiting campaigns. It took its theatrical line more and more from that of the Proletkult movement in the Soviet Union, and this was developed in Britain as agit-prop street theatre, or, as its founder Tom Thomas called it, a "propertyless theatre for a propertyless class". Plays were rapidly put together for street presentations around rent struggles, evictions, factory accidents, and exposing the lies of the capitalist press.

In the 1930s members of the Communist Party and close sympathisers were also responsible for setting up the Workers' Film and Photo League, the Workers' Music Association, and a variety of pro-communist literary journals and magazines such as *Left Review*, *Poetry and the People*, *Proletarian Literature* and others. The Left Book Club, founded as a result of a collaboration between Communist Party bookshop workers and Victor Gollancz, had, within a year, a membership of 28,000, with 730 discussion groups around the country. By 1939 the Left Book Club was so influential that the Labour Party felt obliged to proscribe its membership.

From the 1930s onwards the Communist Party created a network of bookshops in many major towns and cities, mainly selling Party literature, but also selected fiction and poetry. The Labour Party failed to start any bookshops of its own. Time and time again after that early wave of enthusiasm for cultural activity at branch and constituency level in the 1920s and early 1930s, the Labour Party turned its back on the educational and cultural needs of its membership, as it was rapidly turned into a machine for winning local and national elections.

The Labour MP Richard Crossman recalled with some frustration his experience campaigning for Labour in the 1945 election in Coventry, particularly the failure of Transport House to provide much literature to candidates and local parties:

> "Every twopenny or threepenny pamphlet at open air meetings is immediately snapped up and usually paid for with silver, for which no change is asked. I believe if we had in stock 40,000 Penguins we could have sold them easily.

The free literature is glanced through and tossed away. What we sell is taken home and thrown back at us at the next open air meeting in the form of precise and thoughtful questions."

The history of the Labour Party is sadly littered with such missed opportunities to create a political – as well as an electoral – constituency of its own.

The best-known example of a fully developed "party culture" is that of the German Social Democratic Party between 1890 and 1914, the "heroic age" of German socialism. Largely because so many working-class people felt excluded from the forms and institutions of bourgeois culture – to a much greater degree than in Britain in the same period – politically active workers associated with the trade unions and the SPD formed their own "counter-culture" of sports and cultural organisations. They also felt obliged to do this by a pervading sense that as the working class they had an historic mission to fulfil, that as the bearers of the new society they had a duty to develop its institutions. The SDP looked forward to the day when "work would dissove in culture and culture in work".

The German workers movement had its own pubs, with many landlords playing leading roles, a situation in complete contrast to Britain, where publicans have traditionally been leading Tory sympathisers and voters. There was a strong sporting culture, with large workers' cycling organisations, hiking movements and gymnastic clubs. Politically conscious workers organised their own orchestras, bands and choirs, and celebrated their own festivals, such as large annual demonstrations commemorating the Revolution of 1848, the Paris Commune of 1871 and the deaths of well-known German socialists such as Lassalle and Wilhelm Leibknecht. The trade unions had their own buildings, libraries, newspapers and publishing houses. There was also a strong workers' theatre movement, a large network of friendly societies, co-operative shops and housing projects. Along with work and home, club life and culture was the third main area of everyday life in the workers movement of this period.

From one generation to another

One of the most important functions such political cultures have served in the past has been to create a social setting in which a new generation can be socialised into the political and social values of its parents, rather than having to build again the arguments for socialism generation. Much oral history has revealed the powerful formative

influences which the early Socialist Sunday Schools, the Clarion Fellowship meetings, the weekend schools and cycling holidays and the many other kinds of social clubs had on the young people who were recruited into these activities by their parents, and which then influenced them for the rest of their lives. We suspect that many of the young people who have been attracted to the socialist politics of Red Wedge (and for that matter to Militant, Labour Party Young Socialists and other parties and sects), have come into socialist politics as something rather novel and strange. A line of inheritance such as there was has been broken.

Of all the pre-war organisations in Britain, perhaps it is only the Woodcraft Folk (the Co-operative Movement's youth organisation) which has survived and is currently enjoying a resurgence of interest. The Woodcraft Folk's long-standing commitment to a respect for the natural world, along with its pacifist internationalism, now appeals to many parents who have become interested once again in these old "socialist" issues, through such campaigning organisations as CND, Friends of the Earth and Greenpeace, amongst many others.

One gets an acute understanding of the importance of there being a "political and organisational" inheritance to be handed down in the following description by Annie Davison of her memories of Scottish political culture in the 1930s, taken from Jean McCrindle and Sheila Rowbotham's collection of oral histories, *Dutiful Daughters*:

> "There was also for many years a Socialist Music and Drama Festival in Glasgow, and many young people learned a lot about music and drama in those annual competitions. These children are now mostly the backbone of our Scottish institutions, like in the trade unions, acting, orchestras, writing, poets, CND, Women's Lib, etc. It was very well-organised in Glasgow and all of the socialists – the Labour voters as you would call them nowadays – they were really early socialists who wanted a change of society and their children to learn as much as possible about these things. They didn't want to have to – they didn't just want to vote Labour. They wanted their children to learn that socialism was a way of life and what was good for one was good for all, and so this was the moral attitude they had."

How damning that comparison seems between one generation defining themselves as the participants of an active socialist culture and a next generation simply being defined by the fact that they voted Labour!

In the post-war period many of these ancillary socialist organisations disappeared, as cold war politics made it increasingly suspect to

belong to anything other than mainstream Labour Party or trade union organisations. One by one the popular front organisations founded in the 1930s died out. When CND first started in the late 1950s, even that was a suspect organisation as far as the Labour Party was concerned. Since the war the Labour Party has dissolved its own youth organisation three times, and may be about to do it again. To outsiders it has often seemed more worried about what sort of people are joining the Party than why people leave it.

Though often written off as "apathetic", young people today are as passionately interested in political issues as any previous generation. Each generation finds its own particular dominant issues, and today the causes of anti-racism, women's rights, anti-apartheid, ecology, animal rights and nuclear disarmament are likely to involve many more young people than the politics of the nationalisation of the 600 major companies, the re-establishment of the closed shop, or that long running dispute as to the exact meaning of the phrase "the withering away of the state" in Lenin's *State and Revolution* which has kept tens of thousands of hard-bitten armchair Marxists awake at nights.

In this climate no socialist party can have a correct 'position' on every modern issue, precisely because it must be a body representing (or seeking to represent) a variety of separate and often antagonistic class, trade union, gender and race interests. Its appeal to the next generation is likely to arise from its openness to ideas and issues, to its support for the work of the single issue campaigns (without having in advance to endorse each campaign's every recommendation): from the process of its politics as much as the 'appeal' of its programme. A party which encourages a diversity of campaigning organisations — with which it should have federated relations — rather than being a monolithic organisation, will need to reflect this in its cultural programme. The epoch of the totalising party culture preparing to absorb society into itself is clearly in the past. In its own way it linked the political and the personal. It is hard to locate the strategies of hegemony whereby within civil society a party would fight long-term wars of position to establish a dominant position for its common sense and its institutions in an age when we no longer expect to find a single, all-encompassing truth.

Today it is the new forms of radical politics that have shown themselves most adept at uniting "the personal and the political" (a sentiment which which William Morris would have clearly recognised) in a society saturated much more than its predecessors with the temptations and pleasures, however unattainable, of late capitalism. Their strength has lain precisely in their diversity, their ability to reach people on their own terrain.

This does not, of course, imply that the Labour Party can be absolved of the urgent need to create some kind of educational and social culture of its own. It is one thing to recruit new members, quite another to keep them. There's more to life than meetings. Some lessons can be learnt from the experience of the Italian Communist Party (PCI), which has for many years organised its own festivals, concerts, publishing, newspapers and magazines. For those brought up on the cultural barrenness of British socialism, ARCI, a nation-wide network of arts and recreational projects with over one million members run jointly by the Communist and Socialist Parties, is quite an inspiration. But it has to be recognised that the PCI is limited by its democratic centralism: culture is a means of establishing an identity and reaching people, but remains a one way street.

Red Wedge provides one example of a different form of party culture. Red Wedge organises concerts, festivals, comedy shows, publications, records and videos for, but not on behalf of, the Labour Party. Its aim is not to create a passive army of young Labour voters, but to act as a channel for changing the party itself. In this way culture can be a mobilising force to generate demands and activity rather than passive acquiescence. As a conscience and pressure group represent-ing one part of the movement Red Wedge should be able to develop as a source of ideas, creating the visions and activists of the future, rather than simply being a short-term extension of public relations.

Labour's federal structure makes it, at least in principle, a suitable vehicle for such an approach. If this was to happen one could envisage a range of cultural movements representing black people, women, trade unionists or regions each with its own, independent contribution to the culture of the party. This would be the mirror image of the totalising, all-embracing party cultures of the past. Instead the party would become the medium rather than the source of change, linked through a myriad of arteries and capillaries to the sources of new ideas, visions and ways of organising that come from the movements in society at large.

Towards 2000

British culture has always taken an inordinate pleasure in the past. Richard Hoggart, author of the seminal book *The Uses of Literacy,* describes in detail his attraction to the sensibilities of mid-Victorian rural life evident in the Reverend Kilvert's country diary. G. D. H. Cole argued that the most effective piece of socialist propaganda ever written was Blatchford's *Merrie England,* a rural idyll. Harold Laski said he would rather be governed by the "gentlemen of England than by the Gradgrinds of Coketown". The attraction to a pre-capitalist past (even to the days before the Norman yoke) and the well-documented deference of so many early labour movement leaders have made socialists easy prey for the Opera Class. Small wonder then that when in power, Labour preferred to hand over its funds to the "gentlemen of England" rather than support its own cultural heritage.

Although as individuals some Labour politicians have often been successful broadcasters or fanatical film buffs, as a movement and a party Labour has never felt truly at home with the new technologies of culture. It has always preferred a vision of maypoles and village greens, church and Sunday school, galas and choirs, to the popular forms — the music hall, tin pan alley and pop, Hollywood films and ITV — which have formed a much greater part of the reality of working-class experience in the twentieth century. Even today when slick promotional techniques are being applied to "selling the party", the blind spot remains.

The cost of these attitudes is a failure to shape the future. With rare exceptions, Labour's cultural policies have been responses — responses to the coming of ITV, local radio, cable or satellite, responses to Conservative arts cuts, and responses to the closure of previously commercial theatres or cinemas. As the pace of change accelerates from the CD to the Walkman, the videodisc to the DBS dish, interactive cable to the home video recorder; and as the cultural industries are rapidly restructured by powerful corporations, the left appeals regularly sidelined — impotently bemoaning the loss of the past and half-heartedly calling for a (mythical) better yesterday before *The Price is Right* and the *Sun* came, like Pied Piper, to steal the people's hearts and souls.

Since the late 1970s the colour supplements have often been filled
with futuristic features about the new communications technologies.
Gushing prose about the brave new world of high-tech, and large, bold
diagrams showing the new model household in action — husband on
the telephone in his car to South Korea, the wife at her terminal,
linked by modem to the central office, the kids plugged into computer
games in their bedrooms, satellite TV beamed down through a dish on
the roof, cable bringing opera and local news channels up the front
drive, a printer in the kitchen giving forth the morning paper, a minia-
ture viewing machine for reading a book in the garden. Sandwiched
between the glossy advertisements and the lifestyle advice sections
they painted a potent vision of life circa the year 2000.

It is a vision that has a Tory government stamp of approval.
Margaret Thatcher and Kenneth Baker, the first Minister for Infor-
mation Technology, were eager to be the prophets of a new com-
munications era. Broadband cable and satellites — the key
infrastructures of the new age — would create thousands of jobs and
reverse Britain's industrial decline. A new service economy would
sustain a clean, dynamic and entrepreneurial Albion.

For the pessimist this vision has always been hard to swallow. In
the words of Alastair Milne, former head boy at Winchester public
school, it is a vision of "wall-to-wall Dallas". Like many others he
sees the new technologies breaking down the flood gates of culture to a
torrent of cheap American programming and electronic analogues of
the *Sun,* so driving out all possibility of an indigenous or serious local
culture. Technology would finally triumph over culture. This view
echoes much of the anti-Americanism that has pervaded British
cultural policy since the 1920s. It also echoes the idea that anything
mediated electronically must be spiritually impoverished and
inauthentic. (Quite how a Misty in Roots record or a Tarkovsky film
are more spiritually impoverished than an Italian operatic farce is, of
course, never explained.)

Two entrenched positions have formed. On the one hand is the
coalition of cultural conservatives, liberals and most of the left. As in
the past a realistic fear of the massive power of the US cultural
industries, and their use of new technologies to expand it further, has
combined with chauvinism and luddism. On the other side stands the
massively hyped vision of choice, freedom, and an international
cornucopia of culture and change, based on a coalition of big business,
Thatcherite politicians and a handful of left libertarians for whom the
new technologies offer the chance of finally breaking the grip of the
state. The profound pessimism of many on the left, for whom the
battles over cable or satellite have already been lost, reflects, perhaps,
an underlying view of technology as some kind of life force in its own

right which must suppress humanity in order to survive. Yet, one way or another, the relationship between culture and technology — the question of how technology can be shaped as a tool for realising aspirations and desires — is the central issue in any discussion that goes beyond narrow definitions of the arts to question how meanings are produced and disseminated in modern society.

Instant culture

The impact of technology on culture proved unavoidable. In production, for example, new chip-based techniques are rapidly bringing down the costs of video production (by 1986 a domestic video camera was available for around £1,000), recording music (a 4-track studio now costs less than £1,000), and printing (writing, design, layout and typesetting can all be done simultaneously on a single computerised terminal). On the face of it the barriers to entry are also dissolving, and a new age of diversity has arrived in which any one can start a newspaper, make a record or direct a film.

Revolutions in the means of production are paralleled by the changing technologies of distribution. Just as the birth of mass production depended on the growth of nationwide distribution systems and retail chains, and just as the Hollywood production line depended on its equivalent of the chain store — the cinema — so today production and distribution are evolving in tandem. Although they have been considered largely as means of bringing more television into the home, the advanced fibre optic cable technologies, linked to satellite, could distribute almost any cultural artefact. In theory, if everyone was linked by high capacity cable, it would be possible to order a song or a film from a central library which could then be downloaded to a domestic cassette recorder or VCR. The consumer would be instantaneously charged for the service. The industries making vinyl, pre-recorded tapes, or for that matter pre-recorded compact discs, would become redundant, as would the industries responsible for physically distributing the product.

For the corporation this future brings to a head their fundamental problem: how to control copyright, the right to exploit the words, sounds or images which form the raw material on which their profitability, and the very existence of the cultural industries is based. Battles over piracy of tapes, videos and books pointed to the importance of copyright (the so-called copyright industries contribute over £1,000 million, 2.4% of the total, to GNP) to the UK economy. The roles of Taiwan and South East Asia, where the pirates were as adept at copying a school textbook or a Cartier watch, added a racist under-

current to the struggle. Sustained pressure from the record industry finally forced the Government to introduce a 10% levy on audio tapes in 1986, a small move in the direction of a serious rethink of how the creative work could fit into the new world of proliferating technologies, much criticised on the grounds that it simply shifted resources from consumers to wealthy multinationals, ignoring both the artists, and the possibility of using funds.

In the 1960s a certain Fidel Castro had argued for the complete abolition of copyright, describing it as a pernicious invasion of artistic creativity by the capitalist system. To prove this was more than empty rhetoric he made the grand gesture of offering all Cuban originated material to the world free from the requirement to pay royalties. The quid pro quo was that Cuba would pay no royalties on the American, Spanish or French books, record and films it chose to reproduce. Unsurprisingly the rest of the world was unimpressed, feeling this to be a rather unequal offer.

Copyright, like the parallel issues around patenting, is a major problem for socialists. The idea of turning creativity into a commodity — that a simple tune could belong to someone, as occurred with the celebrated case of the Chiffons vs George Harrison over My Sweet Lord — seems absurd. Stories that call the system into question abound: even as progressive a singer as Harry Belafonte had no scruples when it came to claiming authorship, and subsequently substantial royalties for the Jamaican folk song "The banana boat song". Manipulation of copyright and publishing law has been a favourite tool for exploiting Third World or working-class artists.

Yet, in an age when artists largely perform through forms of mechanical and electronic reproduction, they have a right to some reward for their efforts. The alternative is to payroll all writers, composers and directors, or to follow some form of the Soviet model. In the USSR writers are paid for each impression of a book they produce according to set rules: different payments are made according to category (popular fiction, academic, etc.), with the payments gradually declining to about twenty per cent of the payment made at the time of the first impression.

Unsurprisingly, authors see copyright as a prime source of their independence. For them the key issue is control — the Public Lending Right (PLR) system introduced to the British public libraries was a significant step forward in this respect. Under its terms each author is paid a sum of 0.002p for each time a book is borrowed from libraries, from a minimum of £20 to a maximum of £5,000. So, while authors are rewarded there is also an element (albeit small) of redistribution to less successful authors. One advantage of the fully wired society is that it could massively simplify copyright control. If all cultural

products are passed over the electronic grid, the computerised system can ensure that royalties are instantaneously paid according to standard principles. A PLR type system for redistributing rewards away from the most successful artists towards training, investment or bursaries for young artists would be quite feasible.

A model for redistribution has been implemented since 1982 in Sweden. A levey of 0.02 Kroner per minute of tape (which worked out at around 10p for a C60 tape) creates a substantial fund which is then divided three ways: part is distributed to the copyright owners' organisations for distribution to their members. Another part goes to subsidise live performances, and the third goes in subsidies to record productions involving Swedish music and musicians (including a substantial amount to Caprice, the state record company). Allocation is decided by a sub-committee of the Council for Cultural Affairs.

The privatisation of pleasure

Technologies are also changing the ways in which culture is consumed. The massive consumer demand for computers and VCRs which emerged almost overnight at the beginning of the 1980s has been far more important than any government moves on cable and satellite. A mass market for home computers created a mass market for computer games, and subsequently for increasingly sophisticated interactive computer books. The explosion in video ownership (to over forty per cent of "TV homes") created a nationwide rental network, and more recently a burgeoning market for video sale as the price has fallen towards that of more familiar cultural commodities like books and records.

The shift towards greater spending on cultural hardware (TV sets, VCRs, hi-fi, etc.) as opposed to services has also meant that entertainment is increasingly located in the home. The growth in take away catering, canned beer, has gone hand in hand with the decline in audiences for cinema, football matches and pubs. The privatisation of pleasure — driven by basic economics — has become a fundamental issue, whilst traditions of civic, municipal, and public cultures are being swept away. In their place, fragmented cultures are being formed by the market — specialised TV channels for consumption in the home, and specialised "life-style" based entertainments in the city centres. When television is available at around 2p an hour, why bother with the expense and trouble of travelling to the city centre (most local theatres and cinemas have long disappeared), going out to eat, risking increasingly violent streets and arranging for child care? As leisure time increases (on top of the massive increase in unemploy-

ment, the average number of hours worked by full-time workers has fallen by 100 hours per year since 1975), the great majority of it is still spent in the home — over a third in front of the television.

For those who come from a privileged background of higher education and material security, facts such as these can most easily be read as confirmation of deep cultural pessimism, evidence of the long, unstoppable march of Mammon (usually shrouded in the Stars and Stripes). Authentic cultural forms, and authentic relationships between producer and audience, are being replaced with the lowest-common-denominator synthetic products of the electronic market. But it is a view that runs the risk of self-fulfilment. Cultural pessimism closes off thought about how the future can be shaped differently.

Part of the problem lies with how technologies are seen. Raymond Williams has consistently argued that technologies are products of particular social systems and are in turn gradually shaped to fit into them. The pessimistic, determinist view that technologies shape society is at odds with history. One obvious example is the way radio was originally widely seen as point to point (rather like CB) until real demands and interests turned it into a mass communications medium. Williams also describes the pressures which combined to create the domesticated television set — on the face of it a very inferior product for audiences brought up on the cinema. From this perspective it is clear that new technologies will be developed according to the pressures of their social environment, within a capitalistic sector the most important factor being perceptions of future profitability. Subject to these pressures they may have a damaging cultural effect, limiting diversity, and an adverse industrial effect as they are used as tools to shed labour. But these uses are neither predetermined nor unalterable.

In the case of cable, for example, the colour supplement vision sees the technology rapidly crystallising as a means of restructuring consumption through teleshopping, finance through home banking and culture through premium film or arts channels. Alternative possibilities become increasingly hard to conceive. The left's pessimism about technological change depends also on an uncritical view of how the products of mass communications are used. The mass media are seen as a one way street, a hypodermic syringe down which the manipulations and ideologies of capitalism are fed to a mindless audience. The Channel 4 series *Open the Box* (1986) helped to debunk this widespread prejudice by showing what happened when cameras recorded households watching television. Far from the stereotyped image of passive receptivity, the films portrayed people hoovering, chatting, eating and hugging, sometimes blithely oblivious to the images being beamed at them, sometimes highly critical.

The development of "leisure" shows in a different way the limits of traditional socialist approaches. The idea of leisure being formally supplied developed alongside the spread of formal, full-time employment. Rather than just being "free" time, leisure became the time to spend money, where work was the time to earn it. Within local government, leisure also became seen as part of a broader provision of welfare and services.

Municipal leisure provision undoubtedly brought opportunities for people who could never have been able to afford the costs of swimming pools or football pitches within a market economy. But equally the municipal baths and sports centres have so often adopted a familiar character — unmotivated attendants leaning against paint-peeling walls, showers that don't work, out of date equipment, or alternatively, giant impersonal recreation centres — buildings in which neither the workers nor the users have reason to care. Against a background of spending cuts, the municipal leisure sector is also being increasingly bypassed by private provision. From leisure parks like Alton Towers through to the hundreds of sports and health clubs, gyms and dance studios, the private leisure sector is booming.

The usual response of the left is to denounce the mickey mouse nature of the industry, the low pay and poor conditions of the workers. Given the claims of government ministers such as Lord Young that tourism and leisure are the great hope for the unemployed, this response is correct. The Lord Young vision of the leisure society is of a massive increase in consumption: more holidays, more eating out, more theme parks and more sports centres. The problem with this vision is that it shows only half the picture. Leisure is also about writing, walking, talking, breeding canaries, dress-making, gardening or growing food, none of which involves consumption of organised provision in the same sense. Beneath the mythology of the leisure society is a fundamental divide between a consumption-based view of leisure (which may well divide society between those privileged enough to be active, gaining status and self-respect from work, and those in a state of enforced leisure) and a vision based on self-organisation.

Identity and difference

There is also another, and equally fundamental, dimension to the issue. In any society an important part of oppression is the denial of meanings and identity to the powerless. In modern Britain vast resources are used to bolster the identity needs of professional, white men. The skills of the best scriptwriters, designers and film-makers

are devoted to paeans of praise to them in advertisements, films, television programmes, magazines and pop videos. And one reading of the history of arts funding is of a similar kind of embellishment of the lifestyles and self-images of the English elite. To this the traditional socialist response has been to counter the exclusive styles of the elite with the universal availability of a civic or municipal culture.

In the last years of the twentieth century the limits of these approaches are becoming clear. One reason is that they ignore the ways in which identities are formed. Within a capitalist society, beset by inequalities of power, the best strategies for survival often involve creating alternative, exclusive realms which reject dominant codes. These can take a million different forms, from youth sub-cultures to the leisure pur suits of angling, cycling, karate and judo, country music or the brass band. What makes them effective is that they define an identity through difference. The thousands of clubs, societies and associations detailed in the recent study of voluntary cultural activity on two working-class estates in different towns, "Organising Around Enthusiasms", point to the vitality of this area, which offers exclusivity democratically to all.

These ways of organising leisure counterpose self-activity and self-definition to both the blandness of municipal provision and the domestic privatisation of the new communications technologies. Leisure, after all, originally meant "letting do", a long way from the connotations of passivity and consumerism that the word now has.

What implications does this have for state policies? The answers are not too different from those for cultural policy in general. Alongside straight provision, local authorities need to look at ways of developing an arm's length relationship with leisure organisations. Politically this requires an understanding that people's needs are different and that the state is ill-suited to meeting them all directly and in one blanket programme. Instead of seeking to bring all activities under a public sector, the state needs to develop the idea of a social contract. Such a contract means that in return for financing independent or autonomous forms of provision and activity the state has the right to influence employment practice, wages, equal opportunities and the audience that is served.

If, for example, someone wants to start up a sports club for young mothers with a crèche attached, or for young Asians wanting to learn martial arts or for the elderly; if they have the seriousness of purpose to be able to draw up a plan and to develop a team of people to run the club, local councils should be able to fund them using equity and loan finance as well as grants. In return for financial assistance (as well as possibly training in management and accounting skills) the council is

allowed to monitor financial results and employment practice, to ensure fair wages and trade union access, to encourage ways of involving the workforce in decision-making and to keep track of who actually uses the facilities. Such a system would guarantee the social benefits of funding while leaving the running of an organisation to those best qualified.

In this way pluralistic leisure provision will go hand in hand with the appropriate economic instruments: a shift from the state as all-encompassing provider to the state as enabler and catalyst.

The important point is that a shift away from standardised, centralised provision is, in the long term, the only way of competing with a purely commercialised leisure sector. In order to be truly equal you have to be equally different. In the closing years of the twentieth century the certainties both of a Reithian public service and of Morrisonian welfare are equally vulnerable. The alternative to creating new spheres of independence and autonomy will be cowboy provision and the spiv economy.

The political inadequacy of the old municipal forms points to the need for a socialist alternative that is more than a rearguard action to preserve the public, shared means of communication against the fragmenting, differentiating demands of the market and the ideologues of the new right. The starting point, in culture and leisure, is a respect for the need and value of difference and experiment, and a recognition of the limitations of the mass, standardised public socialism of the past. A socialist cultural policy can no longer be a one way street of imposed collectivism. It needs to be more humble, less ambitious to shape the world in its own image, and more willing to permit different groups to develop their own world views and pleasures.

The market alone, for all its dynamism and concern to meet unmet wants, is incapable of sustaining diversity except on its own terms. Within the media a commercial system based on advertising can only define minorities in the language of marketing. Other minorities — people with disabilities or the unemployed — are of no interest, and, being unable to generate advertising revenue, are left without means of communicating. In culture and leisure more generally, the market exacerbates existing inequalities of wealth, power and identity. The state, meanwhile, cannot encompass the diversity of aspirations, cultures and experience that coexist in Britain today, and is unable to develop its own authentic public culture.

Admitting this also involves a recognition of the limits of any simple, Gramscian strategy of hegemony. To establish gradually a dominant common sense, both within existing cultural institutions and within independent socialist ones, presupposes a more coherent and consistent world view than socialism can lay claim to in the

1980s. Many of the radical demands of women, of black people, gays, of workers and consumers, the unemployed and the employed, are not consistent, not easily brought together under an all-embracing socialist or Labour umbrella. Allowing a hundred flowers of diversity and contradiction to bloom also helps to guarantee that culture can remain a radicalising, challenging force under a socialist government.

Local and national, or regional and international?

In describing the cultural role of the state in Britain, we have seen how much it has been in the vanguard of creating a national culture. From the acquisition of works of art to the propagation of Standard English by the BBC, a metropolitan, national culture has been counterposed both to regional cultures and to the threat of overseas invasion from America. The national state has used the trappings of culture to embellish itself, to locate it within the national traditions of pageantry, of a particular kind of Englishness that appropriates the work of people like Elgar and Betjeman and the Evelyn Waugh of *Brideshead Revisited* within a wider Eurocentric great tradition. Few questioned that the great institutions of British culture — the BBC, Arts Council, RSC, ROH — should be national institutions. Regionalism was never really accepted in the Arts Council, and when the Regional Arts Associations were set up in the 1960s it was despite, rather than because of, the national body.

Lord Feversham, the first chairman of the standing conference of Regional Arts Arts Associations, recalled being received at the Arts Council with "the feeling that one is some kind of orange three headed martian with antennae sprouting from the forehead who has just landed by flying saucer in Green Park".

With the coming of new technologies the whole basis of a national culture is called into question. Cable is eulogised for its potential to create genuinely local programming — community channels or channels geared to communities of interest; satellite broadcasting by its nature transcends both the controls of national governments and the limits of national boundaries; and the use of new technologies has been a key weapon for the corporate restructuring of the world's communications industries. An exemplary case is that of Rupert Murdoch's News Corporation. In its annual report it boasts that it "publishes more than 80 newspapers and magazines in the US, UK and Australia. Their combined circulation is 60 million copies a week, three billion a year, which means that News Corp sells more

periodicals than any other publishing company in the western world." News Corp also has a substantial stake in Reuters, the world's biggest information agency, in addition to stakes in papermaking, commercial printing, airlines and tourism and energy production.

But the keys to the company's strategies are to be found in the electronic media. In Australia it has long owned the TEN network. In the US NewsCorp bought Twentieth Century Fox for $525m and Metromedia (makers of Dynasty among many others) for £2bn, to create a fourth network. It also owns the market leaders in satellite broadcasting — Sky Channel in Europe and Skyband in the US: bypassing national controls and regulations Sky Channel is already changing the face of European broadcasting with audiences much larger than many national channels.

There are two ways of responding to these pressures. One is to recognise that the end of national boundaries is often no bad thing. Afro-Caribbeans in Brixton could have more in common with Moroccans in Paris than with their upper-middle-class neighbours in Dulwich. Saatchi and Saatchi, apostles of the virtues of global advertising, point out that there are "probably more differences between Manhattan and the Bronx than between Manhattan and the 7th Arrondissement in Paris". So far, European cooperation against the American threat has taken the form of countering *Dallas* on its own ground. But a radical EEC could equally develop public service at an international level in the form of DBS channels for Europe's ethnic minorities, cross-Europe religious or environmental channels (or even an international socialist channel), and partially funded through levies on the mass audience channels such as Sky.

In the area of information, trade unions are already actively developing international networks based on computer links to keep up to date with each other's struggles and to coordinate responses to the strategies of transnationals. During the US airline pilot's strike in 1985, satellite links were used to beam broadcasts (which included a pop video of the strike song "We are Family — a United Family") to locations around the country. Space bridging, which was used to link US and Soviet war veterans on TV is another idea with massive potential.

The second part of a response is to develop regionalism. The Arts Council report "The Glory of the Garden" called, in its rather inept way, for a devolution of resources away from the metropolitan centres. Labour has taken this a step further, saying that all funding should be devolved to regional arts associations, with the national institutions funded directly by central government. A more radical version of this would involve strengthening regional bodies to give them much greater powers of investment and economic development, as well as

the power to award franchises for local radio and cable systems, powers which are currently held by Whitehall.

A more decentralised structure, perhaps including directly elected representatives, couldn't fail to be more representative than the Arts Council, which has actually become *less* representative as the years have passed. There were thirteen women amongst its first 66 Council members, for instance, but only nine amongst the next 66; black people have been almost totally unrepresented; no one under 30 has ever been a member. Direct elections, held as with the 1986 ILEA election alongside local authority polls, would initially pass control to political party lists. In the longer run, however, a politicisation of cultural policy would be no bad thing. It would almost certainly weaken the control of the parties while simultaneously forcing them to think more openly about what kind of culture and communications deserve support.

Culture and arts

No society lives by bread alone. Alongside the world of material production, distribution and exchange, there has always existed a parallel world of creation and the dissemination of meanings. This was the world of the artisan and the folk singer, the storyteller and the priest, the painter of frescos and the dramatist. Today it is the world of the copywriter and film director, the rock star and the second violinist, the news editor and novelist. In a few years the computer artist, the holographer and the sky bridging controller will join them. But only some of these activities have ever been allowed into the exclusive world of "art". Photography, invented in the 1830s, was only finally accepted to the ACGB canon in 1967.

Arguments about what art is have provided hours of pleasure for intellectuals and artists the world over. McLuhan said that art is whatever you can get away with. Tony Banks, when chair of the GLC Arts and Recreation Committee, once used the memorable phrase, "The arts show people at their best" in the course of arguing, successfully, for more money. As a concept art's primary role is ideological: to embellish the pleasures and self-respect of some (usually the metropolitan elites) and to downgrade the pleasures of others.

In the last 100 years this sphere has undergone a massive transformation, almost entirely untouched by government policies for the arts. Allied to new technologies of reproduction and distribution — the printing press, the cinema, the gramophone, the radio, the television and the video — organised capital, working through a

market system has penetrated ever more deeply into culture. Gradually the symbolic sphere has become incorporated within the economy. The old gate-keeping institutions — church and state, universities and schools — have found themselves in often bitter conflict with the untrammelled market.

The closing years of this century are bringing strange twists to this tale. Media multinationals such as McGraw Hill or Pearson are investing millions in new educational packages which largely bypass teachers. Meanwhile organised religion is beginning to recognise the broadcasting audience as its most receptive congregation.

The conflicts between the economic demands of the market and the social requirements of a capitalist society are well known, though it is only in the last twenty years that organised capital has become deeply involved in promoting and selling counter-cultures (as when in 1969 CBS launched a series called "The Revolutionaries are on CBS", with Che Guevara style promotional material). It is a contradiction that becomes acute in the Thatcherite view of the world. On the one hand there are calls for a truly free market in broadcasting, and populist calls for giving the public what they want, while at the same time the results — video nasties and sex and violence on screen — are reviled and, as in the case of video, brought under new regimes of censorship.

Justifications for funding particular cultural works are rarely made in explicit or strategic ways. They are framed instead by certain key words — excellence, standards, seriousness, imagination — and kept closely to the chests of the practitioners and *cognoscenti*. Only rarely do justifications have to be made — as in the wake of the media outcry over the Tate bricks. In part this is a reflection of the problem faced by the *cognoscenti* and the critics. Amidst a post-modernist ethos of difference, diversity, contradictions and play, the guiding principles of cultural institutions — the protection of excellence, the "great tradition" — simply dissolve.

And if these institutes are ultimately accountable to the state, which is their patron, why should the state subsidise the very forces which call into question the legitimacy of law, the need for work or a hundred other totems? (In the 1979 Arts Council report, the then Secretary General discussed whether funds should be given to theatre groups which openly call for the overthrow of the state! The solution, classically liberal, was to argue that artistic merit must override all other considerations: now, under Rees Mogg, the Arts Council has simply cut grants to groups like 7:84 and Red Banner.)

The striking fact of arts support in Britain is that it is, in fact, and despite all the monetarist rhetoric of Rees Mogg or Lord Gowrie, pre-capitalist in form, a semi-feudal relic dressed up in the language of

efficient managerialism. It derives its forms of intervention from those of renaissance patronage. It views popular culture and commerce with disdain. And for all Rees Mogg's attempts to portray himself as a prophet of a new electronic middle class, his heart still resides amidst the warm glow of antiquarian books.

Even in its supposedly most modern forms — such as corporate sponsorship — it actively copies the ways in which art would serve to enhance and embellish the glory of the patron. Even more significant is the fact that the very forms of culture that are supported are by definition those that cannot be sustained in a capitalist economy: funding for opera, classical music and theatre occurs precisely because they are no longer commercially viable. The pressures on local authorities to support cinemas reflect a more modern form of this phenomenon, whereby the state picks up the forms left behind by the economy.

This inevitably means that funding is biased towards pre-twentieth century forms, and that bias in turn reflects a class bias. While not discounting the significance of the chap books, ballads and dances of folk culture, the economic base for a truly vigorous and extensive urban popular culture simply did not exist before the second half of the nineteenth century. Concentrating on pre-twentieth century forms inevitably means concentrating on cultural products that were originally created for a wealthy, minority audience. It should hardly be surprising that it remains a wealthy, minority audience that has both the cultural competences and the resources to enjoy these forms.

This is not to deny the importance of public support in bringing about cultural change. Many of the best writers have depended on grants or bursaries, the most innovative groups have needed a John Peel to get their music heard, while the most progressive programme-makers have undoubtedly been aided by the public service requirements placed on their employers. The art schools and colleges of the 1960s and 1970s provided opportunities for bright working class people who went on to dominate rock music, fashion and design. In each case people have been given the chance to make mistakes. Through mistakes creative change is possible.

Monopoly and diversity

It is a notorious feature of the cultural industries that even the largest corporations make disastrous decisions. Britains' largest cultural conglomerate, Lew Grade's Associated Communications Company,

was destroyed by a single error: the film *Raise the Titanic*. The vast majority of records or films lose money, financed by a handful of successes that rapidly accrue economies of scale. Because the success of a cultural product is never predictable most companies have to overproduce systematically. Only one in nine singles records and one in fourteen LPs break even. In theory this should mean that the market is adventurous and experimental. In practice, and because the large record companies are almost entirely geared to transnational audiences, experiment takes place only within very narrow boundaries. EMI may well have signed up the Farmers Boys "just in case Duran Duran didn't work out", but they are unlikely to sign up a Yorkshire folk group or a Bengali dance band.

The cultural industries have also always been vulnerable to monopoly. Electronic means of distribution and reproduction confer massive advantages in economies of scale to those who can serve a mass market. The six Hollywood studios have retained their position for half a century, despite powerful anti-trust moves in the 1940s. Five companies effectively control the world record industry. The narrow base of control in Fleet Street has yet to be seriously challenged despite visions of diversity based on low-cost new technology. In broadcasting, networks rapidly form in deregulated systems.

The weakening of public controls in broadcasting and the broader marketisation of information and communication can only strengthen these inherent trends. There will undoubtedly continue to be new-comers, the Robert Maxwells and Richard Bransons of the 1990s, the exceptions that prove the rule. But it will be more important than ever that anti-monopoly measures — restrictions on ownership, forced divestiture of companies, investment in alternatives — are as central to cultural policy as funding for galleries, theatres and concerts.

As we approach the year 2000 the quantity of information on paper, disc, tape or travelling through the airwaves will doubtless continue its exponential rise. While we are bombarded by ever more billboards, messages, injunctions and corporate come-ons, the attractions of a cultural policy geared to "few but roses" may well become compelling. A policy of concentrating on a few centres of excellence may well be appropriate to supporting a dead culture. There can be no doubt that the standard of performance of the classics in music has never been higher. Creating a living, changing culture is much more difficult.

No funding policy can itself create a Joyce, a Mozart, a Bob Marley or a Virginia Woolf. Any policy that sees that as its goal will surely fail. What it can do, however, is to support a general level of cultural activity, parameters of access to the means of communica-

tion, space for experiment and a certain level of employment. Where is the arts equivalent to the massively successful "Sport for All" campaign? If an Alexandre Dumas is discovered, who can in turn create employment for another 8,000 people (the estimated effect of the writer's career in the printing and publishing industries), then so much the better. In the meantime, a socialist policy ought to make provision so that as many people as possible can choose their own forms of recreation and social life, sometimes as individuals, sometimes as members of organisations, sometimes as practitioners, sometimes as consumers or as members of audiences. Diversity of choice and an end to the redundant and self-defeating antinomies of "high" and "low" should be the watchwords of a radical arts policy. Socialism deserves its Saturday night out, as well as its earnest Sunday morning.

Conclusions

What would happen if Labour came to power?

This book has been written with a sense of urgency. For the first time for many years there is now a strong possibility that the Labour Party might regain power at a national level within the next two years. Yet Labour is still a long way from being able to project a radical and attractive policy for the arts and culture. It remains constrained by the dead weight of the past in the form of lingering attachments to the traditional arts and a deep puritan suspicion of the modern forms of popular culture. Despite advances in recent years it still lacks a coherent media policy, capable of encompassing both community newspapers and satellite broadcasting. Meanwhile the important new movements around community arts and the arts of the "new communities" developing out of distinctive women's ethnic, gay and lesbian cultures, do not in themselves address directly what we see as some of the most crucial cultural battlegrounds of the late 1980s.

These battlegrounds lie largely outside the scope of traditional arts policies. We believe that it is no longer enough for a socialist policy to call, for example, for more community artists to be sent to the estates, for gallery charges to be scrapped, for the Arts Council to be reformed or for a small network of community recording studios to be set up; unless it can also begin to tackle the problems of how key monopoly distributors such as W. H. Smith's and John Menzies can be taken into social ownership, of how the Murdoch empire can be broken up, and of how support can be given to an independent, self-sustaining cultural economy, it will be condemned to marginality. Successful intervention in the macro-dynamics of the cultural sector is, for us, one of the key long term tasks of a radical cultural policy. Without such an intervention the cultural movements of "the new communities" will continue to run the risk of being marginalised, co-opted and eventually destroyed.

This sort of intervention is also vital if the economic strength of the British cultural economy is to be exploited in the historic task of bringing Britain back to some form of full employment. Youth culture, alongside its offshoots in style, fashion, music, and design has been one of the few areas of the economy successfully to make the transi-

tion to the late 1980s, creating jobs and finding new international markets. Arts policies have almost totally ignored it, while economic development programmes have preferred the more orthodox problems of manufacturing and services like tourism and catering. Meanwhile media policy has largely been seen as a personal prerogative of the Prime Minister, used primarily to service short-term party political needs.

The costs of not having a coherent strategy for the arts and communications are more than economic. Allowing the new media to develop along the lines of Fleet Street, mortgaged to international capital through wilful neglect, would be unforgivable. To the extent that such a lack of policy allows other, more powerful, international forces to determine the nature of change, it admits defeat from the start.

Alongside work done as part of the GLC's London Industrial Strategy, at GLEB and other local authorities and enterprise boards, we hope that this book will be part of a shift towards a more forward looking and relevant cultural policy. Our shopping list outlines the kind of fundamental institutional reforms that would be needed before such a shift could become a reality at the national level. The key existing cultural institutions such as the BBC and Arts Council are tired and out of step with their times. They belong to a time when the British elite could unproblematically universalise its own beliefs and prejudices.

Happily that time is past. (A recent survey of young people showed that their favourite television channel was, perhaps surprisingly, Channel 4, a choice which we believe is significant and deserves serious attention.) The new institutions will have to be both more clearly accountable, and more clearly open to the demands of audiences. They will have to be able to support experiment, risk and innovation without the contempt for the popular that linked the traditional elites to the avant-gardes. And they will need to recognise their wider social and economic responsibility: art has never been sovereign and accountable only to itself. When resources are scarce, the arts have no inherent rights over the demands of health, education or any other area of public spending.

In this section we outline some of the basic institutional elements of the policy. In the first place the existing division of responsibilities between the Office of Arts and Libraries, the Department of the Environment, the Department of Trade and Industry and the Home Office needs to be urgently rationalised by the creation of an integrated *Ministry of Arts and Communications.* On its own such a reform would do little. But without it there is no prospect of a coherent national approach to the range of policy issues that will undoubtedly

face Governments in the last years of this century.

Such a Ministry would be responsible for overseeing the development of the sector as a whole, establishing a National Media and Cultural Industries Enterprise Board to invest in strategic areas in the press, music, and publishing, a Film Finance Board for funding film and video productions, providing funding towards regional boards (which would also be funded through local taxation), directly funding national arts institutions, museums and galleries, overseeing broadcasting regulation, establishing training bodies, establishing a framework for levies and redistribution of the proceeds, developing copyright law, and ensuring the divestment of multinational press and other holdings.

Alongside such a Ministry some form of elected broadcasting authority will be needed to supersede the current role of the IBA and BBC board of Governors. As technologies of transmission proliferate regulation will inevitably become more complex. An elected body, including co-opted members from voluntary organisations, national and local Government, would establish sub-committees to regulate different parts of the system — ITV channels, licence fee funded channels, cable channels. It would be responsible for the allocation of the licence fee between different services, the allocation of national franchises, and issues such as rights of reply. Alongside the Ministry it would be responsible for determining policy with respect to new areas of broadcasting. This national Broadcasting authority would operate under statute with a responsibility to ensure that broadcasting reflects the full range of cultures and perspectives in British society. Having an elected base it would have a legitimacy and independence from Government impossible in the present, patronage-based system.

Alongside a National Media and Cultural Industries Enterprise Board, elected regional development boards need to be set up responsible for investment, grant aid and regulation of some of the local media. These boards would combine directly elected and co-opted members. They would provide the base of democratic accountability that has been so lacking in the past. Some argue that democracy would sound the death knell of experiment and excellence, diverting state support to a bland, populist mush, and that only the *cognoscenti* can be trusted to understand the vanguards of cultural change. Though we have our doubts as to the cultural literacy of many local politicians, there can be little doubt that many local authorities have shown themselves far more receptive to the real vanguards of cultural change than the Arts Council which recently identified the growth of early music societies as the key musical development of the early 1980s.

Local boards would be funded both from local taxation (following an updating of local Government arts and general economic powers) and through central Government. Just as at a national level an enterprise board would probably work best with relatively autonomous units within it (responsible perhaps for investment in women's publishing, or black music, or new printing technologies) so at a regional level groups of officers should be able to make investments independently rather than passing all decisions through a single, probably overcautious, committee.

Alongside new institutions new criteria are needed for appraising funding choices, which encompass the creation of work, and the needs of audiences as well as a wider set of aesthetic considerations that break free from redundant divisions between high and low art. The capitalist world has made enormous strides in understanding the ways in which people use and enjoy its products. Unless the public sector can develop its own categories and techniques for understanding how leisure services, community radio stations or arts centres are used and perceived it will deserve to be ignored.

Blueprints have a habit of remaining blueprints. The more detailed and structured they are the less chance there is of them ever turning into reality. The details of the programme advanced in this book and of how the local, national and indeed transnational state can begin to influence transnational corporations, will of course have to emerge from practice and experience.

More important, perhaps, than the detailed policies are the principles that underlie them. In the long run we are calling for a major conceptual shift that may prove difficult for those for whom art is still exclusively about theatre rather than television, easel paintings rather than design, live opera rather than recorded music. It will require a shift towards understanding the modern popular arts as commodities are produced, marketed and distributed by industries dependent on skills, investment and training, and a development away from older pre-industrial ideologies of art that emphasised personal development and the sacrosanct value of individual self-expression (but for only a few).

Programmes and parties

Political parties in Britain often seem better suited to fighting elections and winning power than retaining it. Once elections are won the key men (usually) are whisked off to Whitehall in their limousines until the ballot box beckons again four or five years later. It is a sign of the degree of integration of the Labour Party within the parliamentary

system that in the past all campaigning stopped once Labour came to power. This is one, among many, reasons why Labour lost much of the spirit and feel of an oppositional movement.

In a volatile three party system, however, parliamentary politics are bound to be more intensely contested. The inherent instability of the system means that all parties must, in a sense, become campaigning parties all the time. If a government comes to power with a slender or non-existent majority it will have no choice but to campaign and electioneer, consolidating political constituencies that it has won and reaching out to new ones. In such a situation a radical cultural policy could be crucial: it could be implemented quickly, it would be highly visible and it could exemplify other parts of the programme — such as commitments to internationalism and disarmament, to the rights of women, ethnic minorities and gay people, to the creation of a fully employed and participative society.

When the 1981 GLC administration came to power it had almost no plans or ideas for cultural policy. Two of its key innovations, the community arts and ethnic arts committees were not set up until nearly a year and a half after the election. The cultural industries programme, which in many ways questioned the broader arts policies of the GLC, only really came into operation in the administration's final year. The vote winning potential of an exciting and radical arts policy was not understood at first. Only towards the end of its life did the GLC begin to feel confident with sophisticated strategies for using the media and culture as means of defining its identity and winning mass support. If like a minority government at a national level, it had been forced to face an election within its first two years, the Labour GLC might well have been crushingly defeated.

Luckily Labour can learn from these experiences rather than being condemned to repeat them. The first lesson is that policies need to be well developed before the limousines call round for their new ministers. The second is that cultural policies can be successfully integrated into the presentation of a broader programme for change. They are visible, accessible and attractive because they show people at their best. The tradition of tackling the arts on a half-hearted paragraph hidden at the back of a manifesto is one that we could do well without.

Thirdly, Labour in power will urgently need to develop a cultural identity for its social and economic programme; the three are not exactly unrelated, or certainly shouldn't be, and a degree of political courage is needed to allow some innovatory policies to follow their own course.

Giving support to independent cultural organisations such as young people's centres or community radio stations may, of course,

create centres of opposition and criticism. This was why the present Government backed down from its plans to license community radio stations. We would hope that Labour has the political maturity to appreciate that independent, lively cultural organisations are probably more socially healthy and effective than dependent ones. Politicians often find it hard to keep their sticky fingers off the media particularly when, like the BBC, they are directly dependent on the government. One of the greatest dangers for those in power is that they begin to believe in their own propaganda, failing to realise the value and virtue of criticism. Under Thatcher, we have seen precisely this process taken to ludicrous lengths. We would argue that a culturally and politically aware movement, however critical, will actually make it easier for a radical government to sustain support and deliver on its promises than either "dirigiste" state-licensed propaganda machines or the quietist obsession with a notion of political neutrality to which both the Arts Council and BBC claim to adhere and to which Labour in power has traditionally deferred.

Pick 'n' mix

This concluding section consists of a shopping list of jobs that a new government would need to do. It makes no claims to be a fully formed, comprehensive blueprint. We would expect that any new government would develop its policies in dialogue with those who will be affected, with workers and trade unions in the relevant industries, with consumers and amateurs, voluntary groups and local authorities. Plans can no longer be fed downwards by small groups of technocrats. Unless they are based on dialogue and on the experience of those who live and breathe the different areas of cultural activity, party programme and plans, for all their impressive structures and details will be revealed as empty vessels.

 The key principles which will support the detailed policies will be:

★ a recognition of the need to mix investment and grant aid techniques to deal with the nature of the cultural mixed economy. This will mean applying a more complex set of criteria for appraising projects than either a traditional investment body or a traditional arts funding body. To do this successfully it is essential that different goals are clearly understood. Where, for example, there are social and cultural goals separate from commercial considerations (perhaps the funding of a special training programme for women, or providing an unviable product for a disadvantaged group) these would be separately funded.

★ the need for explicit criteria for funding decisons. Unless the rationale for spending public resources on culture are visible and can be pointed to in the case of individual funding decisions, the arts will always remain in danger of becoming the private preserve of a self-defining, unaccountable, elite.

★ the need for forms of democratic accountability to replace the patronage models of the past. Without establishing democratic lines of communication, and the need to account for spending on programming decisions, ordinary people have no means of influence and no redress against the institutions which claim to serve them. Alongside other, long overdue reforms such as a Freedom of Information Act, the establishment of elected bodies is a necessary rather than a sufficient condition for opening up lines of information and communication and bringing decisions out of the committee rooms of Whitehall.

Day One – reforming the institutions

The first priority for a new government should be to embark on a visible high profile programme of cultural activity (festivals, radio stations, etc.) alongside institutional reform of the structures of cultural funding and regulation.

A second priority would be to introduce into all arts funding four basic criteria for funding: **cultural** (aesthetic contribution, innovation, distinctiveness), **social** (contribution in terms of work or pleasure to social groups otherwise ignored by the market or mainstream institutions), **employment** (creation of flexible opportunities for paid work and training), **audience** (ability to meet unmet needs of hitherto neglected audiences).

A third priority would be to establish the principle of rights to paid educational and cultural leave (up to 150 hours per year) for all workers beginning with the state sector, and possibly the creation of an "Open University for the Arts" providing opportunities for unemployed and home-based workers.

The following list is meant to be indicative of the directions a radical government intent on genuine change might take:

1. Creation of an integrated **Ministry of Arts and Communications** with cabinet status responsible for arts funding, investment in the cultural industries, broadcasting regulations, etc. In short a ministry responsible for the economic, social and cultural development of the arts and cultural industries bringing together roles currently played by the Office of Arts and Libraries, the Department of Trade and Industry, the Department of the Environment the Home Office, the Department of Education and

Science and the Treasury.

2. Establishment of a **Media and Cultural Industries Development Board** responsible for commerecial investment in innovative media and cultural enterprises, particularly those meeting unmet needs and those involving new forms of social ownership. The Board would also be responsible for funding the acquisition of companies divested under the implementation of anti-monopoly measures. A clear demarcation line would be drawn between the use of commercial loans for investment and the use of grants to underwrite specific programmes for developing equal opportunities policies and other social objectives.

3. Move towards the creation of directly elected **Regional Media and Cultural Industries Development Boards** alongside the regional reorganisation of local government, to be responsible for regional funding of arts and cultural industries and the award of local broadcasting (cable and radio) franchise. In the meantime to strengthen powers of autonomous Regional Arts Associations to enable investment and training strategies.

4. Move towards **direct funding** of major national arts bodies by the new Ministry, with local funding removed to regional bodies. Organise winding down of the Arts Council.

5. Reform **local government legislation** on arts funding to include investment in modern electronic forms of cultural production and training.

6. Investigate powers to impose new **taxes** on the commercial sector: a progressive tax to be levied on advertising expenditure to be used for funding the Media Enterprise Board, and a levy on blank tapes and videos to be ploughed back into the base of cultural production through training programmes etc.

7. Create a major **research and evaluation unit** into the take-up of arts and leisure provision with particular regard to: elderly, people with disabilities, ethnic minorities, women and working-class people in general.

8. Immediately set up teams responsible for organising a programme of major popular **festivals** across the country, in association with local authorities where appropriate. These would immediately create work for cultural workers and act as a visible spearhead for other policies. In parallel announce a wide range of open **competitions** in all areas of cultural activity, especially targeted at groups previously excluded from arts funding.

9. Appoint an independent and representative inquiry to advise on future developments in **broadcasting**, with the dual aim of widening choice and creating jobs. It should be committed to full and open consultation with different groups around the country to

investigate: reorganisation and decentralisation of the BBC and the feasibility of creating independent, competing broadcasting corporations linked by a central co-ordinating body; the role of independent producers within such a structure; regulation of DBS within the EEC; expansion of programme making including community channels to serve a cable network; a shift away from the requirements of balance and neutrality towards a principle of reflecting the different perspectives in society.

10. In the meantime the government proceed towards a large scale experiment in **community and specialist radio** stations, alongside ending state harassment of pirate radio stations.

11. All new initiatives and institutions to be based outside London and the South East, alongside a broader programme for **re-distributing the state** around the country (i.e. centres of power as well as routine work such as vehicle licensing, VAT).

12. Enter immediate negotiations with British Telecom (taken back into social ownership) for a national programme of investment into high capacity, interactive **cable** to be linked to local consortia involving local authorities, business and voluntary sector.

13. To pursue urgently means of regulating **satellite broadcasting** through the EEC, and investigate potential for new public channels to be provided at European level.

Other priorities

14. Investigate more effective means of using **anti-monopoly powers** to prevent concentrations of power in press and broadcasting, cross-media ownerships, foreign ownership of key means of communication, and oligopoly in retailing and distribution of cultural products by companies such as W. H. Smiths.

15. Establish principle of rights to paid **educational and cultural leave** (up to 150 hours per year) for all workers beginning with state sector. Establish an "Open University for the Arts" providing opportunities for time out from work, for unemployed and home based workers.

16. Encourage new educational schemes in schools, CFEs, etc. for teaching the new electronic based **cultural literacies** involving video, recording techniques, computer graphics, etc.

17. Work alongside newly formed **National Investment Bank** to develop sector strategies for job-creating investment within cultural industries, e.g. in manufacture of compact discs and Digital Audio Tape, or distributions systems.

18. Investigate role of the **British Council** with a view to a major

overhaul to ensure that it can present a view of living Britain to the world, rather than a vision of old masters and stately homes.

19. Move towards recreation of an independent **National Film and Video Finance** organisation, responsible for investment in British film and video culture.

20. Encourage funding for **common services** aimed at the independent sectors in music, video, publishing: advice on financial and marketing issues, sponsorship of trade fairs, joint export promotions, etc.

21. Move towards greater controls on sexist and racist **advertising**, and wide-ranging bans on tobacco and alcohol advertising.

22. Develop programme for funding **independent cultural centres** to be run by young people, to complement the work of the youth service.

23. Link funding for **national arts bodies** to commitments to greater touring programmes and equal opportunities in training and recruitment.

24. Develop use of **planning powers** and **contract compliance** procedures at all levels to ensure that commercial and funded bodies pursue equal opportunities and socially responsible employment practices.

25. Develop in conjunction with trade unions new **training schemes** similar to the ACCT "JobFit" in arts and cultural industries for hitherto excluded sections of the population.

26. Investigate means of restructuring **DHSS** provisions and pension provisions for those working in the cultural sector and facing "lumpy" earnings life-cycle.

27. Provide access to **training** opportunities for those working in the cultural sector to become aware of administrative, accounting, legal skills.

28. Revitalise the idea of the **cultural component** – the percentage charge on spending on buildings or capital spending more generally, to be allocated to cultural purposes. The principle could be extended to revenue budgets, e.g., to bring a cultural dimension to state industries in modern versions of the GPO's celebrated film unit.

29. Introduce a **Freedom of Information Act**.

30. Develop a programme of joint national and local investment in **venues** for popular music, theatre etc., and refurbishment of local cinemas, particularly outside major cities to develop the model of **community cinemas**.

31. Investment to revitalise role of **public libraries and museums** in the cultural life of the communities they serve, to include widen-

ing range of products available for loan, new daytime services, access to word processing, printing, recording facilities, and expanded outreach work.

32. Develop a cultural programme of festivals, publications, recordings, etc., through the **Labour Party** around key themes of policy such as peace, housing, environment as a means of maintaining the momentum for implementing a radical programme.

How decisions are made

NOW:

Prime Minister appoints:

1. Ministers for: 2. Members of:

Office of Arts and *Arts Council:*
Libraries responsible for funding
responsible for: "living arts"
Arts Council, museums
and galleries, British *BBC Governors:*
Library, BFI, etc. responsible for overseeing
 BBC

Department of *IBA:*
Environment responsible for award of
responsible for local ITV, ILR franchises and
authorities, zoos, historic overseeing activities
buildings, heritage, inner
city projects *Cable Authority:*
 responsible for awarding
Department of Trade and cable licences
Industry
responsible for film,
publishing, tourism,
copyright law

Home Office
responsible for broadcast-
ing, cable and DBS,
theatre and cinema
licensing, censorship

Local authorities: responsible for arts funding, public libraries,
parks, museums and galleries, etc.

AFTER...

Ministry of Arts and Communications

responsible for: overseeing funding and regulatory bodies directly funding national arts institutions, bilateral and EEC liaison on international issues (e.g., DBS)

appoints

National Media and Cultural Industries Enterprise Board

responsible for strategic investments in key sectors + grant aid for social goals (e.g., equal opportunitities)

National Film and Video Finance Board

responsible for funding audio-visual productions and distribution arrangements according to four basic criteria

National Broadcasting Authority

responsible for overseeing regulatory bodies for licence funded services, commercial services

Regional Media and Cultural Industries Development Boards

responsible for regional arts funding, investment in cultural industries, sponsoring events, franchising local and community radio and local cable.

directly elected alongside regional authorities

directly elected by viewers

Current responsibilities of Ministries for arts activities

1. Office of Arts & Libraries

Arts Council
Museums & Galleries Commission
British Library
B.F.I.
Crafts Council
National Heritage
Educational Broadcasting

2. Dept. of Environment

Rate support grant
Public Libraries
Heritage Arts
Countryside affairs
Zoos
Historic Buildings

3. Dept. of Trade

Commercial film making
Publishing
Tourism
Copyright law

4. Home Office

Broadcasting
Cable/Satellite TV
Theatre & Cinema Licensing
Press & censorship

5. Agricultural & Fisheries

Royal Botanical Gardens
Kew Gardens

Recommended reading

In this short list of books we have tried to indicate some of the most useful and up-to-date surveys of contemporary issues in arts and popular culture.

The Press

James Curran & Jean Seaton, *Power Without Responsibility*, Methuen, 1985.
James Curran, Jake Ecclestone, Giles Oakley & Alan Richardson, *Bending Reality*, Pluto Press, 1986.

Theatre

John McGrath, *A Good Night Out*, Eyre Methuen, 1981.
Ralph Samuel, Ewan McColl & Stuart Cosgrove, *Theatres of the Left 1880-1935*, RKP, 1995.

Music

Simon Frith, *Sound Effects*, Constable, 1983.
John Street, *Rebel Rock*, Basil Blackwell, 1986.

Cinema

Vincent Porter, *On Cinema*, Pluto Press, 1985.

Literature

Ken Worpole, *Reading by Numbers*, Comedia, 1985.

Arts Policy

GLC, *Campaign for a Popular Culture*, GLC, 1986.
GLC, *The State of the Art, or the Art of the State?* GLC, 1985
GLC, *The London Industrial Strategy: the Cultural Industries*, GLEB, 1985.
GLEB, *Altered Images: Towards a Strategy for London's Cultural Industries*, GLEB, 1985.
Robert Hutchinson, *The Politics of the Arts Council*, Sinclair Brown, 1982.
Kwesi Owusu, *The Struggle for Black Arts in Britain*, Comedia, 1986.
Owen Kelly, *Community, Art and the State*, Comedia, 1984.

Other titles from Comedia